Dada and Surrealism: A Very Short Introduction

VERY SHORT INTRODUCTIONS are for anyone wanting a stimulating and accessible way in to a new subject. They are written by experts, and have been published in more than 25 languages worldwide.

The series began in 1995, and now represents a wide variety of topics in history, philosophy, religion, science, and the humanities. Over the next few years it will grow to a library of around 200 volumes – a Very Short Introduction to everything from ancient Egypt and Indian philosophy to conceptual art and cosmology.

Very Short Introductions available now:

Available soon:

For more information visit our web site

www.oup.co.uk/vsi

David Hopkins

DADA AND SURREALISM

A Very Short Introduction

OXFORD
UNIVERSITY PRESS

OXFORD
UNIVERSITY PRESS

Great Clarendon Street, Oxford OX2 6DP

Oxford University Press is a department of the University of Oxford.
It furthers the University's objective of excellence in research, scholarship,
and education by publishing worldwide in

Oxford New York

Auckland Bangkok Buenos Aires Cape Town Chennai
Dar es Salaam Delhi Hong Kong Istanbul Karachi Kolkata
Kuala Lumpur Madrid Melbourne Mexico City Mumbai Nairobi
São Paulo Shanghai Taipei Tokyo Toronto

Oxford is a registered trade mark of Oxford University Press
in the UK and in certain other countries

Published in the United States
by Oxford University Press Inc., New York

British Library Cataloguing in Publication Data

Data available

Library of Congress Cataloging in Publication Data

Data available

ISBN 0-19-280254-2

3 5 7 9 10 8 6 4 2

Typeset by RefineCatch Ltd, Bungay, Suffolk
Printed in Great Britain by
TJ International Ltd., Padstow, Cornwall

Contents

List of illustrations

The publisher and the author apologize for any errors or omissions
in the above list. If contacted they will be pleased to rectify these at
the earliest opportunity.

Acknowledgements

My thanks to Paul Stirton for encouraging me to write this in the first place. Beyond that I am extremely grateful to Kate Tregaskis, Katharine Reeve, and Neil Cox for their comments on the manuscript.

To Benjamin

Introduction

Question: How many Surrealists does it take to change a lightbulb?

Answer: A fish.

Everybody knows something about Dada and Surrealism. Dada, born in 1916 and over by the early 1920s, was an international artistic phenomenon, which sought to overturn traditional bourgeois notions of art. It was often defiantly anti-art. More than anything, its participants, figures such as Marcel Duchamp, Francis Picabia, Tristan Tzara, Hans Arp, Kurt Schwitters, and Raoul Hausmann, counterposed their love of paradox and effrontery to the insanities of a world-gone-mad, as the First World War raged in Europe.

Surrealism, Dada's artistic heir, was officially born in 1924 and had virtually become a global phenomenon by the time of its demise in the later 1940s. Committed to the view that human nature is fundamentally irrational, Surrealist artists such as Max Ernst, Salvador Dalí, Joan Miró, and André Masson conducted an often turbulent love affair with psychoanalysis, aiming to plumb the mysteries of the human mind.

For many people Dada and Surrealism represent not so much movements in 20th-century art history as 'modern art' incarnate. Dada is seen as iconoclastic and confrontational; Surrealism as similarly

anti-bourgeois in spirit but more deeply immersed in the bizarre. But why Dada-and-Surrealism? Why are they yoked together? They constitute two movements but are regularly conflated. Art historians have traditionally found it convenient to generalize about Dada 'paving the way' for Surrealism, although that was only really the case in one of Dada's locations, namely Paris. This book will certainly rehearse that story again, but it will also present these movements as distinctly different, so that they can be played off against each another. Dada, for instance, often revelled in the chaos and the fragmentation of modern life, whilst Surrealism had more of a restorative mission, attempting to create a new mythology and put modern man and woman back in touch with the forces of the unconscious. Such differences touch on important distinctions which I have aimed to make as vivid as possible.

More than any other art movements of the last century Dada and Surrealism now permeate our culture at large. Surrealism especially has entered our everyday language; we talk of 'surreal humour' or a 'surreal plot' to a film. This very continuity means that it is difficult to place them at one remove from us in 'history'. Critical and historical accounts of both movements have admittedly become more and more elaborate. Dada, which might be thought to be anti-academic, is now widely studied in universities. Similarly monographs on notorious Surrealist artists such as Dalí and René Magritte are ubiquitous. But very often the sheer plethora of information is dazzling, and we lose critical distance.

Conscious of this problem, I have structured this book around key thematic issues. Chapter 1 charts the historical development of Dada and Surrealism, and deals with the assumptions involved in approaching them together. Chapter 2 looks in detail at the way both movements disseminated their ideas, particularly in terms of public events and publications. In the process, it shows how they established a dialogue between art and life. Chapter 3 looks closely at aesthetic questions, focusing on poetry, collage, and photomontage, painting, photography, object-making, and film. Issues of anti-art and the positioning of each movement within modernist aesthetic debates are centrally important here. The last two chapters highlight recent research, by both myself and

others, in line with current historical perspectives on the movements. I examine Dada and Surrealist attitudes to a range of key topics from irrationalism to sexuality, before focusing closely on their politics. The book concludes with some reflections on the afterlife of the two movements, particularly in relation to recent art.

My main concern has been to ask the questions of Dada and Surrealism that correspond to our current cultural preoccupations. For instance identity – whether racial or sexual – is a central concern for many of us, and Surrealist artists, such as the French photographer Claude Cahun or the Cuban painter Wifredo Lam, were pioneers in addressing it. But to appreciate the force of their concerns it is necessary to recreate the contexts to which they were responding. Similarly, given Surrealism's current popularity in culture at large (for example, the ubiquity of Dalí's works on posters) it is safe to assume that the 'darker', unconscious aspects of our psychic lives, which were celebrated by both Dada and Surrealism, are now widely thought to be 'positive' things. However, in cultures where Fascism was once powerful many would question the virtues of surrendering to the irrational, while modernist critics have argued that, however anti-bourgeois they might have considered themselves, the Dadaists and Surrealists simply helped to extend the range of experience which bourgeois culture could assimilate into its system of values. In our 'postmodern' culture we all too readily aestheticize our darker motivations and impulses. This book looks at the historical roots for such attitudes and clarifies why, and in what contexts, they were once 'radical'. In doing so, questions about our own motivations might inevitably arise.

This kind of enquiry, which does not necessarily place Dada and Surrealism on a pedestal but seeks to establish why they are still such vital forces in our culture, seems particularly pressing given that contemporary art is very much in thrall to these movements. This can be made apparent by glancing at a work by Sarah Lucas, one of the most visible British artists of the 1990s.

Lucas's work reveals a continuation of the desire to shock that was once the stock-in-trade of Dada. At the same time, she uses substitutions or

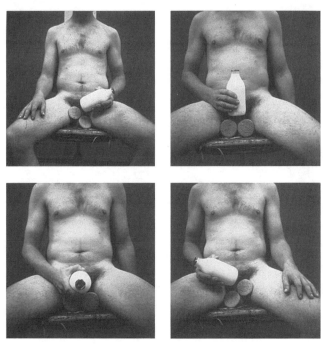

1. Sarah Lucas, *Get Off Your Horse and Drink Your Milk*, set of photographs, 1994

displacements of bodily imagery that were once the currency of Surrealism. Her work implicitly relies on the achievements of Dadaists and Surrealists such as Marcel Duchamp, Man Ray, and René Magritte. But does Lucas's work simply confirm that Dada-style shock has become institutionalized? Or does it build on this tradition in a culturally significant way?

These, it seems to me, are the kind of questions that a contemporary engagement with the implications of Dada and Surrealism might throw up. By the end of this book, we should be well placed to answer them. The central task of the coming chapters, however, is to establish the key historical and thematic contours of Dada and Surrealism.

Chapter 1

Dada and Surrealism: a historical overview

The early 20th century was a period of tumultuous change. The First World War and the Russian Revolution profoundly altered people's understanding of their worlds. The discoveries of Freud and Einstein, and the technological innovations of the Machine Age, radically transformed human awareness. In cultural terms, the novels of Joyce or the poetry of T. S. Eliot – the former's *Ulysses* and the latter's *The Waste Land* were both published in 1922 – registered distinctively new 'modernist' modes of feeling and perception characterized by a marked sense of discontinuity. Hence the theorist Marshall Berman sees a simultaneous sense of exhilaration and impending catastrophe, reflective of the fractured conditions of life at the time, as defining modernist sensibility.

Early 20th-century art movements powerfully reflect this new mind-set. Daringly innovatory in technical terms, movements such as Cubism and Futurism, both of which were at their height around 1910–13, moved beyond the calm surface of traditional painting to probe the structure of consciousness itself. Arguably, though, it is to Dada and Surrealism that we should look for the most compelling explorations of the modern psyche, not least because both movements placed considerable emphasis on mental investigation. Dada partially saw itself as re-enacting the psychic upheaval caused by the First World War, while the irrationalism celebrated by

Surrealism could be seen as a thoroughgoing acceptance of the forces at work beneath the veneer of civilization. This chapter summarizes the overlapping histories of both movements, but, first of all, what attitude links them to the other art movements of the early 20th century?

The 'avant-garde'

More than anything else, Dada and Surrealism were 'avant-garde' movements. The term 'avant-garde', which was first employed by the French utopian socialist Henri de Saint-Simon in the 1820s, initially had military connotations, but came to signify the advanced socio-political as well as aesthetic position to which the modern artist should aspire. Broadly speaking, art in the 19th century was synonymous with bourgeois individualism. Owned by the bourgeoisie or shown in bourgeois institutions, it was a means by which members of that class could temporarily escape the material constraints and contradictions of everyday existence. This state of affairs was challenged in the 1850s by the Realism of the French painter Gustave Courbet, which, by fusing a socialist agenda with a matching aesthetic credo, arguably represents the first self-consciously avant-garde tendency in art. By the early 20th century, several key art movements – such as Futurism in Italy, Constructivism in Russia or De Stijl in Holland, as well as Dada and Surrealism – were pledged to contesting any separation between art and the contingent experience of the modern world. Their reasons for doing so were inflected in different ways by politics – the Constructivists, for instance, were responding directly to the Bolshevik Revolution in Russia – but they tended to share the belief that modern art needed to forge a new relationship with its audience, producing uncompromising new forms to parallel shifts in social experience. For the cultural theorist Peter Bürger, writing in the 1970s, the mission of the early 20th-century European avant-garde thus consisted in undermining the idea of art's 'autonomy' ('art for art's sake') in favour of a new merging of art into what he calls the 'praxis of life'.

Dada and Surrealism thus shared the defining avant-garde conviction that social and political radicalism should be bound up with artistic innovation. The artist's task was to move beyond aesthetic pleasure and to affect people's lives; to make them see and experience things differently. The Surrealist goal, for instance, was nothing less than the French poet Arthur Rimbaud's call to 'change life'.

As already noted, the modern art of the early 20th century – the pictorial fragmentation of Picasso and Braque's Cubism, for instance – represented a startling break with traditional artistic conventions. The standard art-historical way of understanding this break is to see it as representing the legacy of late 19th-century French artists such as Gauguin, Seurat, Van Gogh and Cézanne, alongside a general shift of sensibility that had been effected by European Symbolism in the 1880s and 1890s. In the paintings of Cézanne and Gauguin, for instance, space was flattened out and colour distorted in a radical departure from naturalism. Such conditions paved the way for the abandonment of Renaissance pictorial conventions, such as linear perspective, in Picasso's watershed painting of 1907, the proto-Cubist *Les Demoiselles d'Avignon*. At the same time German Expressionism and French Fauvism experimented further with expressive, non-naturalistic uses of colour.

Dada and Surrealism were certainly beholden to Cubism and Expressionism, alongside Futurism, for their new pictorial languages. Cubist collage, for instance, led directly to the Dadaists' development of 'photomontage'. But the Dadaists and Surrealists would have been deeply uncomfortable with the idea, implicit in much of Cubism, that formal innovation alone provides a rationale for art. Much as the art of Cubism aimed to shock or disorientate its viewers into rethinking their relations with reality, it was ultimately 'autonomous' art; art about art. For Dada and Surrealism the stakes were considerably higher than this. Like certain other 20th-century art movements such as Futurism, which reflected the speeded-up,

multi-sensory world in which people in the first decade of the 20th century were living, Dada and Surrealism were committed to probing experience itself.

This commitment to lived experience meant that Dada and Surrealism were ambivalent about the idea of art as something sanctified or set apart from life. This is a fundamental point, and it is why it is inappropriate to treat Dada and Surrealism as identifiable stylistic 'isms' in art history. In actual fact there was comparatively little stylistic homogeneity among the artists involved, and literature was as important to them as visual art. It would be more accurate to describe these movements as ideas-driven, constituting attitudes to life, rather than schools of painting or sculpture. Any form, from a text to a 'ready-made' object to a photograph, might be used to give Dada or Surrealist ideas embodiment. In Dada a basic distrust for the narrowness of art frequently translated into open antagonism towards its values and institutions. At this point, therefore, we should put generalities aside and examine the overall historical outlines of Dada. A discussion of Surrealism will arise out of this.

Dada's origins: Zurich and New York

The 'myth of origins' of Dada centres on one man, the poet and theorist Hugo Ball, and the cabaret bar, called the Cabaret Voltaire, which he opened in the Spiegelgasse in Zurich in February 1916.

The cabaret was initially modelled on prototypes in cities in which the itinerant Ball had previously lived, namely Munich and Berlin. Like the cabarets there, it offered a heterogeneous programme of events ranging from the singing of street ballads to the recital of poems in the dominant Expressionist mode. Ball's early associates at the cabaret, all of whom were expatriates like himself, included Ball's girlfriend the cabaret performer Emmy Hennings, the Romanians Tristan Tzara and Marcel Janco, a poet and artist

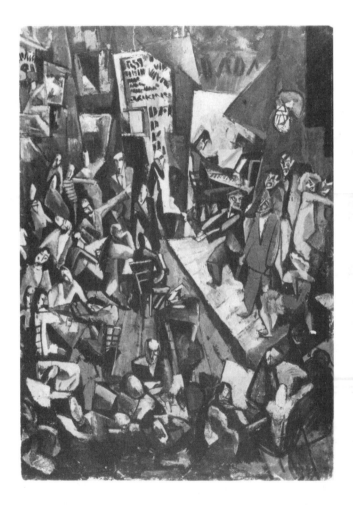

2. Marcel Janco, *Cabaret Voltaire*, oil on canvas (photograph of lost work), 1916

respectively, the Alsatian poet-artist Hans/Jean Arp (his alternating name reflecting his dual French/German nationality) and Arp's partner, the Swiss-born textile designer and dancer Sophie Taeuber. Shortly they would be joined by the German poet Richard Huelsenbeck and later by the likes of the German writer Walter Serner and the experimental filmmakers Hans Richter, from Germany, and Viking Eggeling, from Sweden.

Although the performance events staged by this group at the Cabaret Voltaire were initially fairly conventional, they quickly turned into provocations. Tzara was to recall a particularly notorious performance in July 1916:

> In the presence of a compact crowd . . . we demand the right to piss in different colours . . . shouted Poem –shouting and fighting in the hall, first row approves second row declares itself incompetent the rest shout, who is the strongest, the big drum is brought in Huelsenbeck against 200.

To a degree such confrontational proceedings followed in the wake of a series of performances in Italy and other European locations by the Italian Futurists during 1909–13. Although their knowledge of Futurism was partial, Cabaret Voltaire performers such as Ball and Huelsenbeck were aware of its leader Marinetti's experimental poetry or 'parole in libertà' and the Futurist performers' confrontational use of cacophonous or 'bruitist' barrages of noise. Ball developed a form of 'phonetic' poetry in which made-up words jostled rudimentary linguistic fragments. His 'Karawane' of 1916, a poem which appears to mimic the trumpetings and slow movements of a caravan of elephants, begins 'Jolifanto bambla ô falli bambla'. Other Dada poets and performers joined forces to recite 'simultaneous poems', in which texts were read aloud or chanted simultaneously. To some extent, such techniques were extrapolations from Futurist prototypes. However, Dadaist phonetic poetry was often more uncompromisingly 'abstract' than the Italian precedents, and the Dadaists themselves had little of

the Futurists' faith in technological progress and none of their pro-military fervour.

Dada performances also borrowed elements from Expressionism, the style which had been dominant in German art up until that point, and from which the German-born participants in the Cabaret Voltaire were gradually departing. There had been a cult for African art among the Expressionists, as there had been among the French Cubists, and the performers at the Cabaret Voltaire occasionally engaged in 'negro dancing'. Further primitivizing undertones could be found in the incessant drum-beating with which Huelsenbeck famously baited the audience at the Cabaret.

The artistic activities at the Cabaret Voltaire were diverse. They extended beyond performance poetry and dance to the radically simplified geometrical collages of Hans Arp, which were often displayed during performances. This demonstrates the equality accorded to visual and literary production by the Dadaists, an attitude which was essentially an inheritance from 19th-century cultural movements such as Romanticism and Symbolism, as well as from Futurism and Expressionism. But the group's lack of adherence to any delimited sense of art, and their confrontational ethos, was ultimately determined as much by social and political realities as anything else. Their very reason for being in Zurich was its neutral position at a time when their home countries were involved in the carnage of the First World War. There is an important way in which the Zurich Dadaists equated the war which was raging elsewhere with a conviction that the values attaching to pre-war art were largely decadent ones. If oil painting and bronze-cast sculpture had become synonymous with the interiors of high-class boudoirs, the Dadaists would assemble new structures from bits of paper or from pre-existing objects. If poetry was synonymous with refined sensibility, they would wrench it apart and reorientate it towards babble and incantation. As a group they were united in a hatred for the professionalization of art, seeing themselves as cultural saboteurs, but it was not necessarily art *per se* that they

rejected; rather it was the way art served a certain conception of human nature. In his writings, Arp in particular would equate the art produced prior to the war with egotism and a too-high valuation of humanity. Voicing commonly felt Dadaist sentiments he would later write:

> Revolted by the butchery of the 1914 World War, we in Zurich devoted ourselves to the arts. While the guns rumbled in the distance, we sang, painted, made collages and wrote poems with all our might. We were seeking an art based on fundamentals, to cure the madness of the age, and a new order of things that would restore the balance between heaven and hell.

It is interesting that a fundamentally constructive note is struck by Arp's talk of a curative role for art and a 'new order of things' here. Other Dadaists would be considerably more negative, seeking to destroy art as a concept. Arp himself had an almost messianic sense that it could be reinvented. But what would the coming of Dada represent? Turning to the origins of the word 'Dada', which are profoundly confusing, since various group members claimed to have discovered it in different circumstances, it seems that it was the word's sheer open-endedness that attracted them. Writing in his diary of the Dada years, *Flight Out of Time*, now one of the crucial primary sources for knowedge of the Zurich movement, Hugo Ball recorded that, after a few months of activities at the Cabaret Voltaire, the group began to see the need for a collective publication and hence for some form of label:

> Tzara keeps worrying about the periodical. My proposal to call it 'Dada' is accepted . . . Dada is 'yes yes' in Rumanian, 'rocking horse' and 'hobbyhorse' in French. For Germans it is a sign of foolish naiveté, joy in procreation, and preoccupation with the baby carriage.

By contrast Huelsenbeck recalled that he discovered the word while leafing through a dictionary with Ball and was moved to exclaim that 'the child's first sound expresses the primitiveness, the

beginning at zero, the new in our art'. It is significant that Ball stresses the international mobility of the concept, seeing it as a kind of cultural esperanto, while Huelsenbeck stresses notions of rupture and renewal. Both attitudes were key ingredients of Dada. Beyond this, the word paradoxically stood for everything and nothing. It amounted to a kind of absurd admixture of affirmation and negation, a kind of pseudo-mysticism. Art was a dead religion. Dada was born.

A complication here, however, is that Dada was born elsewhere simultaneously. In 1915 two French expatriates Marcel Duchamp and Francis Picabia arrived at a similar position, at a somewhat greater remove from the European war, in New York. Both artists had been prominent in French artistic circles before the war, but gravitated to America feeling that it would be more receptive to new ideas. Duchamp's Cubist-influenced painting *Nude Descending a Staircase no 2* had found little success with the Parisian avant-garde but had travelled to New York and been a success at the 'Armory Show' exhibition of 1913. By 1915 Duchamp had come to formulate what he described as an anti-retinal stance in relation to the visual innovations introduced into French art by Matisse, on the one hand, and Cubism on the other. Duchamp's distaste for art which appealed solely to the eye rather than the intellect went hand in hand with a cynicism about the effects the machine age had wrought on the human psyche. Humanist rhetoric continued to uphold notions of the soul and romantic love, but, seeing this as self-deluding in the face of society's increasing mechanization, Duchamp and Picabia began around 1915–16 to develop a parodic language of machine/human hybrids, most significantly in Duchamp's painting-on-glass, *The Bride Stripped Bare by her Bachelors, Even* (or *Large Glass*), a work which was to be abandoned as 'definitively unfinished' in 1923.

Duchamp's antipathy towards the 'craft' associations of visual art, and his concomitant belief that ideas should replace manual skill as the prime components of works of art, led to his selection of

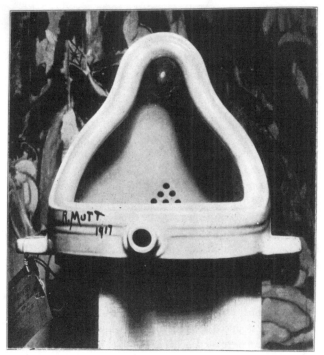

THE EXHIBIT REFUSED BY THE INDEPENDENTS

3. Marcel Duchamp, *Fountain*, readymade, photograph by Alfred Stieglitz as it appeared in the journal, *The Blind Man*, 2 (Mar. 1917)

'readymade' items as art objects from 1913 onwards. Most notoriously, he submitted a men's urinal – playfully signed 'R. Mutt' and titled *Fountain* – for the New York Society of Independent Artists exhibition in April 1917.

The work's rejection by a hanging committee, in spite of a policy whereby payment of a member's fee guaranteed exhibiting rights, became a Dada manifestation in itself.

By this point there appears to have been some knowledge of Zurich

Dada activities on the part of Duchamp and Picabia, but the label itself was barely used in New York until the early 1920s. For this reason the activities of Duchamp and Picabia of 1915–17 are often labelled proto-Dada. Certainly a sizeable avant-garde network quickly developed around the Europeans. It included members of the so-called 'Stieglitz circle' who were associates of the American photographer Alfred Stieglitz, a crucial advocate of avant-garde art in the USA through his 291 gallery in New York, and members of the 'Arensberg circle', named after the wealthy art collectors Walter and Louise Arensberg, who acted as Duchamp's patrons. Its key figures, however, were the American photographer Man Ray, who was to collaborate on a number of later projects with Duchamp, and two people who were to become Dada mascots, on account of their innate eccentricity: the mercurial Arthur Cravan and the German-born writer Baroness Elsa Von Freytag-Loringhoven.

German Dada

In 1918 Dada extended to Berlin as an outcome of the polemical zeal of Richard Huelsenbeck, who had arrived there from Zurich the previous year. In Berlin the validity of art-for-art's sake attitudes were even more clearly undermined by the stark social realities gripping the city. Germany had, at this point, lost the war and was undergoing economic collapse as an outcome of the reparations demanded by France and Belgium. In addition to its economic instabilities, it was teetering on the verge of social revolution in the wake of the Bolshevik Revolution in Russia of 1917. The relatively conservative socialist government in power met forceful opposition from Communists, particularly the Spartacist faction, and reacted with acts of brutal suppression. It is not surprising then that the Berlin Dadaists tended to be highly politicized. Aligned communally as 'Club Dada', they broke down into two groups of friends. One group, which included Walter Mehring, Wieland and Helmut (later John) Heartfield, and George Grosz, were Communist sympathizers (the last three were card-carrying members of the Party). The other group, including Raoul

Hausmann, Hannah Höch, and Johannes Baader, were more sympathetic towards anarchism.

Anti-art in Berlin manifested itself in open opposition to the main aesthetic trend in Germany, Expressionism. Duchampian distase for humanist iconography and the sensual indulgences of 'retinal art' transmuted in Berlin into a discomfort with 'inwardness' and the spiritualized expressive gesture. Despite the fact that Berlin artists such as Grosz and Hausmann had previously worked in graphic idioms attuned to Expressionism, Richard Huelsenbeck now berated the previous artistic generation in a key manifesto of 1920 asserting 'On the pretext of carrying out propaganda for the soul, they have, in their struggle with naturalism, found their way back to the abstract, pathetic gestures which presuppose a comfortable life free from content or strife.' By contrast, Huelsenbeck argued, a new art – that of the Berlin Dadaists – would be 'visibly shattered by the explosions of last week . . . forever trying to collect its limbs after yesterday's crash'.

Not surprisingly the Berlin Dada group spurned traditional painting in favour of Hausmann's phonetic poetry, or the highly original deployment of photomontage techniques by Hausmann, Höch, Grosz, and Heartfield. The fragmentary shards of photographic imagery in their early photomontages, often picturing machinery in a manner broadly analogous to the New York Dadaists, eventually gave way to the apparently seamless surfaces in which John Heartfield specialized. Heartfield's slick montages made use of essentially Surrealist techniques of juxtaposition for savagely satirical purposes. After Berlin Dada's demise in the immediate aftermath of its major public manifestation, the 'Dada Fair' in Berlin of June 1920, Heartfield was to become a merciless commentator on the rise of Nazism in Germany, and his photomontages appeared regularly on the covers of Communist journals such as the *Arbeiter-Illustrierte-Zeitung* (Workers' Illustrated Newspaper).

Elsewhere in Germany there were further Dada outposts. Hanover, considerably more conservative and sedate than Berlin, was home to Kurt Schwitters. Friendly with Berlin artists such as Hausmann and Höch but refused membership of 'Club Dada' by Huelsenbeck for his lack of political commitments and supposedly 'bourgeois' demeanour, Schwitters ploughed his own distinctive furrow, pioneering a form of collage in which urban detritus (discarded bus tickets, sweet wrappers, etc.) was implicitly revalued by being corralled into abstract visual structures. Schwitters adopted the label 'Merz', abstracted from the word 'Commerzbank' in one of his collages, to designate his activities, which by the mid-1920s had extended to the creation of an enormous proto-installation, known as the 'Merzbau', which developed organically through several rooms of his house. In the early 1920s Schwitters established close contacts with artists involved with the International Constructivist movement, as its principles of geometrical abstraction percolated through Germany and Holland. The co-founder of the Dutch De Stijl movement, Theo van Doesburg, was to participate somewhat vicariously in Dada around this time, under the pseudonym 'I. K. Bonset'. He along with Schwitters, Arp, Richter, Hausmann and Tzara attended a 'Dada–Constructivist Congress' at Weimar in September 1922, forging contacts with important German-based Constructivists such as László Moholy-Nagy and El Lissitsky. For a few years sporadic collaborations occurred in and among these groups. In a sense this episode falls outside of Dada proper, at least to the extent that Dada was opposed to purely aesthetic experimentation. But Arp and Schwitters, with their abstract interests, were exceptions to this rule, and the rhetoric of Zurich Dada had in any event included calls for a 'new order'.

Cologne, a far less turbulent city than Berlin, and one which fell under British occupation immediately after the war, provided the setting for a further offshoot of Dada in 1918–20. Here the key figures were Max Ernst and Johannes Baargeld, a pseudonym adopted by Alfred Grunewald with the surname translating as 'money bags', an oblique reference to Grunewald's banker father. Cologne Dada's

membership extended to a more politicized faction including Franz Seiwert and Heinrich and Angelika Hoerle, but the group only really coalesced around one key event, the anarchic 'Cologne Dada Fair' of April 1920 (see Chapter 2). Beyond this, the essentially apolitical but bitterly absurdist collages and photomontages of Ernst, characterized by startling collisions of imagery, set the tone for this Dada formation. As with Duchamp and Picabia's work elsewhere, a savage indictment of the art of the past could be found in Ernst's reworkings of traditional religious iconography.

French Dada

Just as Cologne was positioned in cultural terms between Germany and France, so Ernst tended to look to Paris to a much greater degree than other German Dadaists. He eventually moved there in 1922. Dada in Paris is a complex affair, in terms of its shifting clientele and their allegiances. It was born early in 1919 with the arrival of Picabia, Dada's self-appointed ambassador of nihilism. He had just spent a period in Switzerland during which he had turned up in Zurich, representing, for Zurich Dada's chronicler Hans Richter, 'an experience of death'. Zurich Dada in its final phase was nihilistic in any case, with Walter Serner declaiming a particularly bleak *Last Loosening Manifesto* at the final public manifestation of the movement in April 1919. In Paris Picabia paid host to Duchamp who was revisiting his home country. Duchamp's enigmatic persona, expressed in gestures such as the iconoclastic *LHOOQ* consisting of these letters (producing the French equivalent for 'she has a hot arse' when read aloud) written beneath a reproduction of the Mona Lisa with pencilled-in moustache and beard, quickly elicited the admiration of a group of young Parisian poets grouped around the journal *Littérature*. This group – notably Louis Aragon, Théodore Fraenkel, Paul Eluard, and Philippe Soupault – was effectively 'led' by André Breton.

A charismatic personality in his own right, Breton was profoundly affected by the example of others. Centrally important for him was

the French poet Guillaume Apollinaire, the associate of Picasso and critical advocate of Cubism, who had died in 1918. In many ways Breton was to assume Apollinaire's role as avant-garde catalyst. Another influence was Breton's friend Jacques Vaché, a dandy whose bitter humour (christened by himself 'umour') and sense of futility led him to commit suicide with an overdose of opium, shortly after the Armistice was signed, in 1919. With such precedents in mind, alongside that of Duchamp, Breton developed his own essentially cerebral brand of Dada.

In early 1919 Breton looked to the example of Tristan Tzara whose powerful 1918 manifesto had appeared in the third edition of *Dada*, a magazine published by the Zurich group. 'The Principle "Love thy neighbour" is hypocrisy. "Know thyself" is utopian but more acceptable because it includes malice. No pity. After the carnage we are left with the hope of a purified humanity', wrote Tzara, shifting from the rhetoric of nihilism to that of redemption in familiar Zurich style. Tzara himself arrived in Paris in January 1920 but over the next couple of years Breton, whose tendency to seek coherence of outlook gradually alienated him from the anarchic Picabia, as well as Tzara, inevitably assumed avant-garde leadership.

Paris Dada was bluntly negativistic in tone. Opposed though it was to the right-wing government that had come to power in France after the war, it was rarely overtly political like Dada in Berlin, and far removed from the proto-constructive ethos of Dada's early phase in Zurich. Its key manifestations were a series of public provocations in one of which, in March 1920, Breton read out Picabia's 'Cannibal Manifesto':

> What are you doing here, planted on your backsides like a load of serious mugs . . .
> . . . you serious people, you smell worse than cow dung
> DADA, as for it, it smells of nothing, it is nothing, nothing, nothing.
> It is like your hopes: nothing
> like your heaven: nothing . . .

like your politicians: nothing . . .

like your artists: nothing . . .

Fundamentally, Paris Dada, like Dada manifestations elsewhere, waged war on the outworn rhetoric of art. At the same event, Picabia presented a canvas with a stuffed monkey attached to it surrounded by the words: 'Portrait of Cézanne, Portrait of Rembrandt, Portrait of Renoir . . . '

Surrealism: beginnings

By mid-1922 Paris Dada, the final full-blown incarnation of the movement, had become mired in its own negativity. Its demise was signalled by Breton's organization of a 'Congrès de Paris' which, in aiming to pinpoint the overall direction of avant-garde activity, tacitly asserted that Dada was what it wanted to avoid becoming: another movement in art history. Breton's penchant for cultural politics is evident here. Accusing Dada of 'insolent negation' and a taste for 'scandal for its own sake', he seized the opportunity to reorientate avant-garde priorities. The way was prepared for Surrealism.

Max Ernst arrived from Cologne late in 1922, providing a link with German Dada activities, although not at their most politicized. For a couple of years, between 1922 and 1924, there was a kind of hiatus between Dada and Surrealism, a phase christened by its participants the 'mouvement flou' (indistinct or hazy movement) during which Breton, Aragon, and Eluard, along with newer recruits to the *Littérature* circle such as Robert Desnos and René Crevel, engaged in a variety of experimental activities. Most dramatic of these were the 'seances' in which certain group members, notably Desnos, responded bizarrely to questions when in self-induced trances. An interest in the irrational which had manifested itself in Dada as anti-bourgeois psychic free play was now being systematically explored. While serving as a medical orderly in the French army during the war, Breton had become

acquainted with Sigmund Freud's theories of the unconscious. The psychoanalyst's works were first translated into French during the early 1920s, and Breton and his friends rapidly assimilated the scientific idea of the unconscious to their poetic interests, developing techniques of 'automatic writing' whereby, partly on the model of Freudian 'free association', rapid flurries of writing were carried out in the absence of any preconceived idea. However, a meeting between Breton and Freud in Vienna in 1921 clearly established that Freud had little sympathy for such artistic adaptations of his therapeutic techniques.

By 1924 Breton saw fit to consolidate these tendencies under a label, and after its lengthy gestation Surrealism was born with the publication of Breton's First Surrealist Manifesto.

The word Surrealism had originally been coined in 1917 by Breton's role model Apollinaire, but Apollinaire's rather vague attempts to characterise a new supra-logical spirit in the arts were given greater precision in Breton's 1924 manifesto where Surrealism was said to be 'based on the belief in the superior reality of certain previously neglected associations, in the omnipotence of dreams, in the disinterested play of thought'. The manifesto was essentially a poet's charter; little attention was given to the visual arts at this stage and priority was accorded to 'psychic automatism . . . by means of the written word, or in any other manner'. The fact that this was to be conducted 'in the absence of any control exercised by reason, exempt from any aesthetic concerns' made it clear that Surrealism had inherited one central principle from Dada, which returns us to the thrust of the earlier discussion: the critique of a self-referring autonomous art. Like Dada, Surrealism was dedicated to erasing distinctions between the claims of 'art' and those of 'life'. Naming Freud as the guiding light for the Surrealist project, Breton talked not so much of the aesthetic producer but of the 'human explorer' carrying out 'investigations'. Nothing less than a revolution was envisaged. 'The imagination', it was asserted, 'is perhaps on the point . . . of reclaiming its rights.'

Surrealism began as a literary movement. Its early pantheon of forerunners were French poets and writers such as Arthur Rimbaud, Isidore Ducasse (the Comte de Lautréamont), Raymond Roussel and Alfred Jarry. As the 1920s progressed, visual artists, particularly painters, increasingly came into its orbit, attracted by the ideal of a 'peinture poésie'. Max Ernst, his artistic style decisively affected by an encounter with reproductions of works by the Italian painter Giorgio de Chirico, pioneered what might loosely be described as 'dream painting'.

Central as dreams were as subject matter for Surrealist artists, the process of transcribing them visually necessitated considerable conscious deliberation. As various commentators pointed out, this was counter to the ideal of bypassing the control of reason. Critical interventions like this, demanding a constant re-evaluation of principles, became very much the norm in Surrealism. Indeed, the attack on 'dream painting' prompted the artists André Masson and Joan Miró to produce visual equivalents of the automatism that had long been practised by the movement's poets. Another shortcoming of 'dream painting' was that it could be apprehended all in one go, while dreams, of course, unfold in time. The way was therefore opened for film to respond to Surrealist requirements, and the late 1920s saw the production of two highly significant films: *Un Chien Andalou* (An Andalusian Dog) and *L'Age d'Or* (The Golden Age), both the result of collaborations between Spaniards who had gravitated to Paris, Luis Buñuel and Salvador Dalí.

Dalí's attraction towards Surrealism in 1929 shows how successfully Surrealism managed to recruit new talent. At the same time established names occasionally lent support; Picasso allowed several new works to be reproduced in the Surrealist journal *La Révolution Surréaliste* in the mid to late 1920s without ever officially joining the group. Certain figures became established as mainstays of the movement; the painters Ernst and Yves Tanguy for example. Another mainstay was the photographer Man Ray who, having been a collaborator of Duchamp's in the New York Dada

4. Max Ernst, *Pietà/Revolution by Night*, oil on canvas, 1923, Tate Gallery, London

days, became very much the staff photographer of official Surrealism while also producing his own experimental 'rayographs' (cameraless photographs) and studio studies of nudes. Other individuals sporadically fell in and out of favour with the increasingly autocratic Breton, and several were summarily excommunicated for failing to match up to expectations of

doctrinal or ideological purity. The year 1929 was a watershed in this respect when figures such as Georges Ribemont-Dessaignes, Robert Desnos, Roger Vitrac, André Masson, Philippe Soupault, Antonin Artaud, and the ethnographically trained writer Michel Leiris, in the wake of a specially convened meeting in which they were accused of failing to observe group protocols, were publicly denounced by Breton in his *Second Manifesto of Surrealism*.

In actual fact, there had been a rift for some time between the 'Rue Fontaine' Surrealists, so-named after the street in Paris where Breton lived and held group meetings, and the 'Rue Blomet' faction which incorporated Masson, Miró and Leiris among others. The latter group's penchant for Nietzschean philosophy had always alienated them from Breton and when they began to be courted by Georges Bataille, an ethnographer and writer who emerged as a key intellectual rival to Breton in the late 1920s, mainly via his journal *Documents*, Breton saw the need to act decisively. His Second Manifesto was partly aimed at undermining the appeal of Georges Bataille. As far as Bataille was concerned, Breton's thought was flawed by its idealist presuppositions. Breton's aesthetics, which were rooted in Hegelian dialectics, returned constantly to the notion of the new reality produced when two incompatible images collide. The much quoted exemplification of this for the Surrealists was Lautréamont's extended simile 'Beautiful as the chance meeting on a dissecting table of a sewing machine and an umbrella'. By contrast to such an aesthetic of revelation Bataille advocated what he called a 'base materialism' whereby art sought to confront the lowest or most bestial aspects of humanity. Artists in sympathy with Bataille, such as Masson, therefore tended to produce imagery which, for Breton, could appear gratuitously offensive. A more direct attack on Breton was mounted in the form of the pamphlet 'A Corpse' published by the Bataille camp in 1930. Breton, pictured as a martyred Christ, was lampooned for his censorious judgements and self-importance.

Breton's *Second Manifesto* in any case signalled a shift in the philosophical direction of Surrealism. Previously the emphasis within the movement had tended to be on the contents of the mind, or what Breton termed the 'interior model'. The emphasis was now placed on the interaction between the interior realm and external reality, in a dialectical relationship. This new orientation had repercussions in terms of visual production. In many ways the meteoric rise of Dalí hinged on a revival of 'dream painting' but, ever the career strategist, Dalí ingeniously swung the emphasis of his work away from internal reverie to what he described as a paranoiac 'delirium of interpretation' in relation to external reality. At the same time a veritable cult of the Surrealist object emerged from around 1930, led by Dalí and the Swiss-born artists Alberto Giacometti and Meret Oppenheim. Here the emphasis was on the artist finding an object in the external world which corresponded to unconscious requirements, hence reinvigorating the relations between inner and outer reality. A cult of the 'encounter', which went back to the early days of Surrealism, was simultaneously stepped up. Wandering through a Paris that was magically informed by a hidden network of meanings, the Surrealist flâneur would make himself available to the dictates of 'objective chance'. True to the underlying avant-garde ethos of Surrealism, however, this new engagement with the external world manifested itself more literally in politics.

Surrealism: politics and internationalism

The Surrealists' engagement with politics had begun in 1925 when they opposed the French colonial war in Morocco. By 1927 their passionate opposition not only to France's right-wing government but to capitalism in general led to them joining the French Communist Party. However, from the beginning it proved difficult to square their political inclinations with their artistic aims. How, as internal critics such as Pierre Naville argued, could a political ethos of collectivism be reconciled with the extreme individualism of Surrealist poetry and art? Should a revolution of the mind precede a

social revolution or vice versa? After Breton's group purges of 1929, which were themselves partly predicated on the relative claims of group solidarity and individualism, these questions became particularly pressing. The Surrealists were now forced to respond to the requirements of a new Stalinist regime in Russia. Matters came to a head in 1932 when Louis Aragon officially quit Surrealism in favour of the Communist Party. As the 1930s progressed, 'Socialist Realism' – a legible, realist art for the masses – became the officially sanctioned art of Communism, and Breton's Trotskyist commitment to a cultural-cum-political revolution alienated the Surrealists decisively from Soviet orthodoxy.

Despite such ideological turbulence, Surrealism in the 1930s attracted a number of newcomers. Several of these were women, ranging from the English painter and writer Leonora Carrington, who largely explored mythological themes, to the French writer and photographer Claude Cahun, who produced self-images questioning her own gender identity. Within male Surrealist art, primacy had always been given to the expression of sexual desire, usually conceived of in heterosexual terms, and the 1930s saw the erotic work of the German Hans Bellmer coming to prominence. Violent and morally taboo fantasies were licensed in Surrealism by a cult around the French 18th-century pornographer, the Marquis de Sade, conceived of as an apostle of liberty.

The later 1930s was also a period in which Surrealism, as a set of doctrines, spread both to other European countries and to other continents. In the 1920s Surrealism had attracted important figures from countries such as Spain or Germany to Paris. As the world became more politically volatile in the 1930s – with numerous countries affected to varying degrees by the political polarities of Communism and Fascism – the movement's principles and values appealed to Leftist and anti-Fascist artists and writers in a variety of new contexts. In this sense it often achieved a political potency elsewhere that it was incapable of in France. The first substantial subgroup was formed in Belgium in 1926 by the writer Paul Nougé

and incorporated artists such as E. L. T. Mesens, René Magritte and, later, Paul Delvaux and the photographer Raoul Ubac. By the mid-1930s Surrealism had gained a foothold in Eastern Europe. Two Romanians, Victor Brauner and Jacques Hérold, had been important additions to the Paris group in the early 1930s, but particularly significant was the formation of a Prague group in 1934, its prominent figures being Karel Teige, the collagist Jindrich Styrsky and the painters Josef Sima and Toyen (Marie Cernunová). Both the Belgian and the Czechoslovakian groups had friendlier relations with their national Communist Parties than the Paris group.

In 1936 the important 'International Exhibition of Surrealism' took place in London, serving as the rallying point for a disparate collection of English talents such as the writer David Gascoyne, the painters Roland Penrose and Eileen Agar, and the filmmaker Humphrey Jennings. Large international exhibitions very much provided the symbolic locus for Surrealism by this time. Dramatic staging had always been a distinctive aspect of Surrealism (a small but striking display of objects was shown at Charles Ratton's Paris gallery in 1936 for instance), but 1938 saw their most flamboyant exhibition yet, the 'International Exhibition of Surrealism' held at the Galerie des Beaux Arts in Paris in which the ceiling of the main room was hung with coal sacks filled with newspapers.

That same year Breton travelled to Mexico to cement ideological bonds with Trotsky and the muralist painter Diego Rivera. This established the foundations for a Surrealist presence in Latin America, with figures such as the photographer Manuel Alvarez Bravo and the painter Frida Kahlo being hailed as Surrealists, however much their work dealt with 'local' traditions and concerns. The Surrealists were always voracious in their annexation of cultural and social 'others'. They saw their work as paralleling that of the art of the insane, and often placed their artworks alongside objects such as Oceanic masks. Sometimes this amounted to an insensitive appropriation of quite different modes of

understanding, but with the onset of the Second World War and the inevitable dispersal of the Parisian nucleus of the group, Surrealism as a French-identified phenomenon was forced to adapt to new cultural imperatives.

In 1941 Breton, along with artists such as Masson and Ernst, left German-occupied France via Marseilles, although some of his old allies such as Eluard chose to remain in Paris. Breton's exile proved to be a catalyst in various ways. On the one hand, his visit to Martinique, en route to the US, brought him into contact with the 'Négritude' movement that was under formation in the French colonies, and more particularly with the poet Aimé Cesaire. Surrealism thus truly became a language of the culturally marginalized. On the other hand, Breton's presence in New York from 1942 to the end of the war meant that the foundations were laid for an American response to Surrealism, despite the fact that Breton himself remained defiantly French and refused to learn English.

Before the war the American take-up of Surrealism had been confined to isolated instances, such as the work of Joseph Cornell, who produced poetically allusive tableaux in open-fronted wooden boxes from the late 1930s onwards. With the presence of Breton and several key painters in the US, Surrealism now began to inform the abstract painting that was dominant in New York. Several older New York painters, notably the Chilean-born Roberto Matta and the Armenian-born Arshile Gorky, started to incorporate elements from the painting of Surrealists such as Miró and Masson such as biomorphism (the use of semi-abstract organic forms) and automatism into their work. Such experiments eventually proved instrumental in the development of Jackson Pollock's variant of Abstract Expressionism. Abstraction, underpinned by Surrealist faith in the dictates of the unconscious or the primal, dominated the immediate post-war period in the US but by the mid-1950s artists had begun to rediscover the implications of Dada. Duchamp, who had moved from France to New York just after Breton but whose

influence had initially been more 'underground', now came to be seen as the decisive figure. His concept of the 'readymade' and his interest in mass culture seemed much more attuned to American sensibility and would provide one of the reference points for Pop Art. Given that the readymade had been a Dada invention, it could easily be argued that Dada, rather than Surrealism, set the agenda for post-1945 art in America.

Breton returned to France after the war, but Surrealism could no longer command the intellectual authority it had once had. Existentialism seemed much more pertinent to the changed times. Arguably Surrealism did not re-emerge as a cultural influence until the 1960s, and it was once again Dada's concern with the readymade or with processes of assemblage which caught the imaginations of the most prestigious French artists of the 1950s such as Yves Klein or Arman. Surrealism as a movement certainly continued until Breton's death in 1966, and periodically came up with dramatic flourishes; in the 1959 *EROS* exhibition in Paris, for instance, the ceiling of the opening 'Love Grotto' 'breathed' courtesy of hidden air pumps. But the movement's characteristic devices now arguably bordered on the 'kitsch' and it had nothing approaching the status it had once had. Paradoxically, however, its influence had become pervasive in the world at large. If it had once aligned itself with Communism, its artistic techniques of juxtaposition and disorientation were now fundamental to the advertising strategies of late capitalism.

Dada-and-Surrealism?

The above summaries of Dada and Surrealism are intended to provide the reader with a 'map' which can be referred back to while reading the rest of this book. The narrative they supply is predicated on the idea that Dada and Surrealism are in some sense 'wedded'. This model of Dada-and-Surrealism has been rehearsed almost as a matter of course in anglophone cultures during the past century. It was used to underpin the first substantial historical survey of the

movements, Alfred Barr's exhibition 'Fantastic Art, Dada and Surrealism' at the Museum of Modern Art, New York, in 1936. Later it informed the substantial book by another MoMA curator, William Rubin, *Dada and Surrealist Art*, in 1968. It was further upheld in the important scholarly reassessment of the two movements 'Dada and Surrealism Reviewed' at the Hayward Gallery, London, in 1978. But how naturally do these movements sit together?

It would be argued by some that 'Dada-and-Surrealism' as a portmanteau concept actually betrays a Francophile historical bias. Indeed from the point of view of a committed Germanist it might be seen as potentially misleading. As we will see, 'Expressionism-and-Dada' might imply as valid an historical narrative for someone primarily interested in German-speaking cultures.

To counter this objection we would have to acknowledge that both movements were avowedly internationalist. Certain figures who literally moved over from Dada to Surrealism, such as Picabia, Tzara, Ernst and Arp, also moved freely from one European culture to another and were bi- or multi-lingual. For political reasons, both Dada and Surrealism abhorred nationalist sentiment and tended to see themselves as addressing humanity at large, although it should be noted that the 'universalizing' rhetoric of the early 20th-century avant-garde is widely questioned these days, not least because it was precisely European assumptions that were thought to be 'universal'. However, the fact is that because a very clear, if gradual, transition from Dada to Surrealism occurred in Paris it has become customary to produce a model of Dada-and-Surrealism predicated on what happened in Paris alone, with Surrealism inevitably emerging as Dada's 'destiny'.

In actual fact Dada did not lead to anything approaching Surrealism in Germany itself. In keeping with other big German cities, there was a trend towards *Neue Sachlichkeit* (loosely translated as 'new objectivity') in Berlin and Cologne in the early

1920s. We can see an artist such as George Grosz, who had used elements of intensified realism in late Dada works such as *Grey Day* of 1921, shifting toward this new trend, but *Neue Sachlichkeit* has little in common with Surrealism. It is outward in orientation, tending towards social satire, rather than 'inward'. The characteristics it shares with Surrealism are a concern with heightened realism (the term 'magic realism' was used by German critics), as in certain works by Dalí and Magritte, and a revalorization of painting itself as an activity. If we had to search for a partner to Dada in Berlin, or Zurich for that matter, we would have to go backwards, so to speak, rather than forwards, and look at how closely Dada in these cities was initially allied to Expressionism. Admittedly this was often in a negative way for many of the Berliners, but Expressionist-style masks, for instance, figured prominently in Zurich Dada performances and, although the performances of simultaneous poems and such like at the Cabaret Voltaire signalled a pronounced move away from Expressionist precedents, they were often juxtaposed with song or poetry recitals harking back to the older style.

Similar points could be made about Dada in New York. The ironic machinist works of Duchamp and Picabia were assimilated by young American artists such as Morton Schamberg alongside an indigenous photographic tradition, represented by figures such as Alfred Stieglitz and Paul Strand, in which the machine was often celebrated. Machine iconography would become an element in a drive towards creating a distinctively 'American' art by the early 1920s, and a much more straightforwardly realist attitude to the machine, as part of a so-called 'Precisionist' trend, took hold in the paintings of, say, Charles Sheeler, well before Duchamp left New York in 1923.

It should be clear from all this that 'Dada-and-Surrealism' is in no way a self-evident formulation if developments in all the centres associated with Dada are borne in mind. It misrepresents Dada to a degree. If a microscope were trained on it as a historiographic

construction, 'Dada-and-Surrealism' might even be seen as erected on the basis of, say, Barr's above-mentioned exhibition at MoMA, New York of 1936, or the publication of the French scholar Michel Sanouillet's important study *Dada à Paris* of 1965 in which he argued that Surrealism was the form that Dada took in Paris. Alternatively, the formulation could be seen as based on the attractions of an international figure such as Max Ernst, who moved from Cologne to Paris in 1922, providing possibly the clearest bridge between German Dada and French Surrealism.

There are, however, very good reasons for looking at the movements side by side, not least because their concerns can often be contrasted in a peculiarly telling manner. Both movements prioritized the poetic principle and downplayed the concept of art, endorsing the avant-garde wish to merge art and life. Both presented themselves as 'international' in ethos, and, in its later stages, Surrealism was virtually global. Both were fundamentally irrationalist in orientation.

Beyond this, subtle and significant differences existed between them. Dada was largely anarchic in spirit. The people who held it together, however tenuously – namely Ball, Huelsenbeck, Tzara and Picabia – were highly ambivalent about what they were doing, just as Dada was defined by them as simultaneously affirmative and destructive. By contrast, Surrealism, impelled by the organizational proclivities of André Breton, was much more of a 'movement' in the sense that the word implies direction. The Dadaists were largely unconcerned about making traditionally saleable art objects, while Surrealist artists such as Dalí and Magritte specialized in that most traditional and saleable of techniques, oil painting. Admittedly Breton criticized the commercial preoccupations of certain artists, but Surrealism might easily be termed 'reactionary' if we were to judge it by the standards of Dadaist anti-commercialism and technical innovation. The Dadaists were ambivalent about the values of intellect, seeing excessive rationalism as part of man's downfall, but the Surrealists, in their theoretical writings at least,

paradoxically employed highly intellectual means to investigate unconscious phenomena.

These, of course, are generalizations, and detailed comparisons will emerge from the focused case studies and discussions in the chapters that follow. My approach throughout, as I asserted in the introduction, will be to examine how Dada and Surrealism concurred or diverged around a set of key themes. I have avoided mapping them onto one another as far as possible, but I have nevertheless seen them as inhabiting a common cultural moment bracketed by two world wars. One thing that should be evident from the above historical summaries is how much emphasis they placed on attracting attention to themselves as avant-garde formations. I have mentioned manifestos, the changes of direction signalled by articles in journals, the importance of staged events, and so on. This emphasis on dissemination is highly characteristic of these movements. It therefore provides the thematic foundation for the next chapter.

Chapter 2

'Rather life': promoting Dada and Surrealism

In a poem of 1923, Surrealism's 'pope' André Breton asserted the pre-eminence of life over art, ending with the words 'And since words have become over-rife / Rather life.' The artists and poets attached to both Dada and Surrealism refused to subordinate the experience of life to that of art. Perhaps they were idealistic or naive in trying to reconcile these principles, but it is this level of ambition which characterizes Dada and Surrealism as quintessentially avant-garde cultural formations. How, then, did these movements penetrate into the fabric of daily life? How did they attempt to infiltrate the world beyond the art gallery? How did they promote themselves?

In this chapter I will concentrate on the Dadaists' and Surrealists' penchant for the 'event' – whether a fleeting performance in some obscure location or a well-publicized public happening – and their ability, when they did enter the art gallery, to create attention-grabbing exhibitions. I will also look closely at their journals and their uses of photography.

Quite apart from how Dada and Surrealism presented themselves to the outside world, how did the participants involved in these movements conceive of their relation with that world, i.e. with the phenomenon of social modernity? To help focus this issue, I will look at their relation to popular culture, and how the city itself

was understood by them. Building on the basic narrative presented in the last chapter, certain key 'moments' will be dwelt on in order to build up a collage of Dada and Surrealist 'snapshots'.

The magic bishop and the Dada fair

Let us begin by reconstructing a foundational Dada moment. If we had attended the Cabaret Voltaire on the night of 23 June 1916 we would have been in a room containing a small stage, a piano, and tables and chairs for about 50 people. A photograph of a now-lost painting by Marcel Janco (see Figure 2) shows that there was barely any distance between the performers and their audience. Eyewitness accounts stress the smokiness of the room and the rowdiness of the audience of drunken students, socialist intellectuals, army deserters and vagabonds, as the cabaret was in the 'amusement quarter' of Zurich.

The Dadaist poet Hugo Ball is carried onto the stage. According to his diary:

> My legs were in a cylinder of shiny blue cardboard, which came up to my hips so that I looked like an obelisk ... Over it I wore a high coat collar cut out of cardboard, scarlet inside and gold outside ... I also wore a high blue-and-white-striped witch doctor's hat.

Once positioned in front of an arrangement of music stands bearing pencilled scripts, he solemnly declaims:

> gadji beri bimba
> glandridi lauli lonni cadori
> gadjama bim beri glassala ...

How would we have reacted? The audience probably jeered. On another occasion Ball primed them by saying 'In these phonetic

poems we totally renounce the language that journalism has abused . . . we must return to the innermost alchemy of the word', a statement which goes some way to explaining the sheer absurdity of his incantation. Ball himself was overwhelmed. Finding himself chanting at one point in a liturgical style that transported him back to his Catholic childhood, he was carried off stage 'bathed in sweat like a magic bishop'. Shortly afterwards he left Dada permanently, eventually devoting himself to religious studies.

Other Dada performances at the Cabaret Voltaire reached a crescendo around this time. Virtually re-enacting the traumatic and dislocating effects of the war they were opposed to, the Dadaists unleashed forces which they themselves found unsettling. As a consequence there was a lull in Dada proceedings between mid-1916 and early 1917.

After this, Zurich Dada gradually became 'respectable'. The group moved over to the other side of the River Limmat and held soirées in impeccably bourgeois civic buildings. The Galerie Dada, which hosted a number of events in rooms above the Sprüngli confectioners, would eventually be described by Richard Huelsenbeck as 'a manicure salon of the fine arts, characterised by tea-drinking old ladies trying to revive their vanishing sexual powers with the help of "something mad"'. High admission prices were charged and guest lists drawn up. It is clear from this that Dada, however much we think of it as bohemian in character, rapidly became assimilated to bourgeois norms. The larger point, of course, is that the Dadaists ironically found it necessary to appeal to a well-educated, liberal audience in order to be 'understood'. It is an irony that will continue as a leitmotif throughout Dada and Surrealist avant-garde activity.

The initial scandal of Dada derived from events at which few people were present. Dada thus relied from the beginning on a process of self-mythologization. Another way in which the group

promoted themselves from early on was via group publications, in the wake of avant-garde precedents such as the Italian Futurist magazine *Lacerba* or the British Vorticist journal *Blast*. *Cabaret Voltaire*, the first of the Zurich group's publications, produced in June 1916, was a relatively sober affair, reproducing works by acknowledged avant-garde names such as Picasso as well as the works of the Dadaists. It was even printed in a de luxe edition with original woodcuts. The next Zurich Dada review, *Dada*, of 1917–19 was more daring in design, making use of jarring typefaces, particularly in its third issue. It was also more assertively 'international', with poems by Dadaist contacts elsewhere, such as Francis Picabia and Louis Aragon.

In a sense, though, Zurich Dada, with its legendary cabaret events and its partially hand-printed magazines, was rather 'home-made'. It did relatively little to harness the techniques of modern publicity. We can look to the later Dada Fair in Berlin to see the opposite process occurring.

Modelled loosely, and highly ironically, on a commercial trade fair, this event had a notable precedent in the Cologne Dada Fair of 20 April 1920 which had been designed to cause its audience maximum discomfort. People entered the Cologne exhibition via the public urinal of a beer-hall. At the exhibition's opening they were treated to a reading of obscene poetry by a young girl wearing a communion dress. The works on display included a sculpture by Max Ernst with an axe attached with which to destroy the object. The Berlin event, held at a commercial gallery from 30 June to 25 August 1920, dubbed the 'First International Dada Fair', and consisting of some 200 objects in various media, was equally confrontational, but was set up from the outset with an eye to obtaining the widest possible publicity. The famous photograph of the gallery's main room (Figure 5), which included a stuffed Prussian officer's uniform fitted with a plaster pig's head hanging from the ceiling and a mannequin, constructed by George Grosz and John Heartfield, with an illuminated light bulb

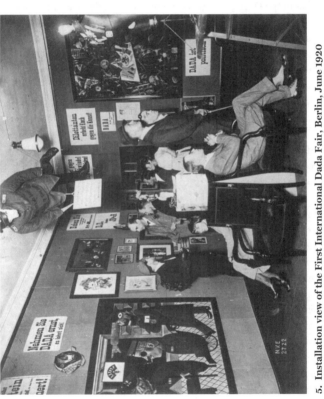

5. Installation view of the First International Dada Fair, Berlin, June 1920

for a head, was reproduced widely. Newspapers throughout the world – from Paris to Buenos Aires – carried articles on the event.

Like the Cabaret Voltaire, the Berlin Dada Fair would have been a profoundly disorientating experience. As we can see from the photograph, the walls of the show included photomontages by the likes of Hausmann and paintings by Grosz or Otto Dix, but these vied for attention with posters bearing slogans such as 'Dada is on the side of the revolutionary proletariat', 'Everyone can Dada' and 'Art is dead: long live the new machine art of Tatlin'. It would have been difficult as a spectator to separate the (anti-)art on display from the polemical barrage. This, of course, is precisely the effect that was sought. The slogan supporting Tatlin is particularly revealing of the overall strategy of the Berlin group. Tatlin, a leading figure of Russian Constructivism whose work they knew only partially, was seen as the embodiment of a new materialist attitude to art, and hence the antithesis of the bogus spirituality represented for them by the Expressionist generation. But the main point about the event is that its sloganeering revealed the Berlin Dadaists' awareness of the increasing power of advertising in daily life. Rather than stand aloof from the processes of the commercial world, they hijacked its strategies to disseminate their message.

The mock trial and the street of mannequins

The two kinds of Dada manifestation we have looked at – one 'home-made' but quickly mythologized, the other manifestly geared towards mass publicity – bore the hallmarks of the movement's desire to overturn or to relativize existing values. Turning to two analogous events – one proto-Surrealist, the other fully so – it is possible to underline some crucial differences between Dada and Surrealism. The first of these reveals the shift from Dada to Surrealism that occurred in Paris, as part of the 'mouvement flou', during 1921 to 1924.

On 13 May 1921 André Breton and a group of his Dada allies, along with a number of literary and political personalities, engaged in a bizarre 'mock trial', set up to test Breton's conviction that Maurice Barrès, a well-known right-wing author, was guilty of 'crimes against the security of the mind'. Looking at a photograph of the event, we can see that a degree of immediate absurdity was involved. The Dadaists themselves were elaborately kitted-out as High Court judges, whilst Barrès – who did not deign to defend himself – was represented by a dummy. However the event was carefully orchestrated and sober in tone, abandoning the spontaneity of previous Dada manifestations such as the Cabaret Voltaire happening discussed above.

In many ways the trial was conceived from the outset as a 'position statement' on Breton's part, as well as a photo-opportunity (a strategy to be discussed further shortly). A few people paid to attend it, but the emphasis was placed squarely on the participants and their ideological viewpoints. Significantly, the participants were not just Dadaists but invited 'witnesses'. They ranged from the nationalist novelist Rachilde to Georges Pioch, a Communist who defended political criminals in the courts. The event was held in premises once used by the Club de Fauborg, a debating society formed during the French Revolution, in which prominent public figures were invited to discuss political matters before a largely bohemian tribunal. (On one occasion a club meeting had instigated the attack on the Bastille.)

Breton and his fellow 'judges' believed that Barrès, whom Aragon in particular had once admired, had betrayed the commitment to the individual conscience shown in his novels of the 1880s and 1890s. In doing so, he had capitulated to the shift to the right in French politics during the First World War. Breton was thus using a Dada event not to disorientate but to examine a coherent set of ideas, albeit ideas which impinged closely on the nascent Surrealist group's concern with the rights of the imagination. The event was also an exercise in cultural politics. To the disdain of

6. The mock trial of Maurice Barrès, photograph, 13 May 1921. From left to right: Louis Aragon, unidentified person, André Breton, Tristan Tzara, Philippe Soupault, Théodore Fraenkel, the dummy representing Barrès, Georges Ribemont-Dessaignes, Benjamin Péret and other Dada associates

Tristan Tzara, who was appalled that Dada could assume a judgemental position, Breton was signalling a move towards a consolidated avant-garde programme, a process which would culminate in the 'Congrès de Paris', mentioned in Chapter 1, and eventually Surrealism.

If the proto-Surrealist 'mock trial' stands in a pointed relation to the spontaneity of the Dadaist Cabaret Voltaire, a much later event, this time an exhibition of the fully fledged Surrealist movement, provides a striking contrast with the Dada Fair in Berlin. On the whole, exhibition installations had been fairly conventional in the early years of Surrealism, and it was not until the later 1930s, largely in order to showcase the increasing internationalism of the movement, that the group started to experiment with exhibition design as the Dadaists had. The large International Exhibition of Surrealism, held at Georges Wildenstein's Galerie des Beaux Arts in Paris in 1938, was a notable turning point.

The talents of the ex-Dadaist Marcel Duchamp were solicited by Breton for this exhibition's installation. Duchamp decreed that 1,200 dusty coal sacks, filled with newspaper, be hung ominously over the main exhibition space, which was lit only by a burning brazier. The works on display were thus difficult to see, and, at the opening, visitors were supplied with flashlights. The nocturnal aspect of the space was further compounded by the presence of two enormous beds, one in each corner of the room.

There were other dramatic flourishes. In the courtyard of the building, visitors could peer into Salvador Dalí's *Rainy Taxi* to discover a scantily clad female mannequin, crawling with snails, perched on the back seat in a cascade of water. Entering the show, they were compelled to walk along the 'Street of Mannequins' and thus notionally to 'choose' among sixteen fetishistically attired mannequins, which might be construed to be 'streetwalkers', each the outcome of the fantasies of a different Surrealist artist.

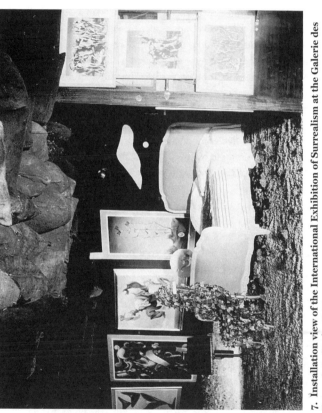

7. Installation view of the International Exhibition of Surrealism at the Galerie des Beaux Arts, Paris, 1938

These effects differ markedly from those used by the Berlin Dadaists at their Fair. Both groups set out to be disorientating, but the Surrealists were obviously concerned with the seductions of unconscious fantasy rather than with the material jolts favoured by the Dadaists. Dreams were obviously invoked by the nocturnal trappings of the main exhibition room at the 1938 show, while the 'Street of Mannequins' encouraged erotic reverie in a way which would have been foreign to Dada's satirical instincts. Like the Dadaists, the Surrealists used exhibition décor as a means of attracting publicity, but their engagement with the world of fashion far exceeded that of their predecessors. The mannequins, for instance, had been borrowed from leading fashion houses and it was no coincidence that Salvador Dalí had started to collaborate on dress designs with Elsa Schiaparelli the previous year. Whilst the Dadaists had parodied commerce at the Dada Fair, the Surrealists could be seen as complicit with it to some degree. Admittedly this was bound up with the international profile they were set on establishing, as two previous international Surrealist exhibitions had been held in Prague and London, in 1935 and 1936 respectively; indeed the Berlin Dada Fair looks almost parochial by comparison. But to some extent the Surrealists risked 'selling out' to the commercial world. If the 'mock trial' of 1921 had been a demonstration of the group's ideological austerity, the exhibition of 1938 revealed how its instinct for publicity could jeopardize its politics. This theme will re-emerge later.

Being Dada, being Surrealist

We have so far looked at events. Let us turn now to people. If Dadaist and Surrealist principles were promoted with maximum strategic flair in their performances and exhibitions, often with an eye to commercial practices, to what extent did the poets and artists of the movements concentrate on personal image-building ? What was involved in *being* Dada or *being* Surrealist ?

We tend popularly to think of Dada and Surrealism as synonymous

with outlandish behaviour, and there are numerous examples within Dada in particular to support this. The most compelling story, perhaps, is that of Arthur Cravan. Born in Switzerland in 1887, a nephew of Oscar Wilde, Cravan lived a restless, itinerant existence in various European locations. In Paris between 1912 and 1915 he published a scurrilous literary magazine titled *Maintenant* dedicated to insulting members of the artistic avant-garde. By 1916 he was in Barcelona where he challenged the world heavyweight boxing champion, Jack Johnson, to a fight. A well-built man, Cravan was an amateur pugilist, given to announcing himself prior to his fights with an improbable list of credentials: 'hotel thief, muleteer, snake charmer, chauffeur', and so on. Whatever his qualifications, he was not a match for Johnson and was knocked out in the sixth round. Not surprisingly, the Dadaist Francis Picabia, who was publishing his peripatetic *391* review from Barcelona, became an enthusiastic advocate of Cravan's and when, in 1917, Cravan turned up in America, Marcel Duchamp got him to deliver a lecture to the 'Society of Independent Artists' (of which more below). Cravan put on a suitably Dada show, arriving drunk, stripping off his clothes, and finally being arrested by the New York Police. He was to disappear completely in 1918. His wanderlust brought him to Mexico, from where he reputedly set out in a rowing boat heading for Buenos Aires, never to be seen again.

Whether or not Cravan committed some symbolic form of Dada suicide is open to debate, but his scorn for convention assured him of lasting fame. In that sense he typifies the Dada belief that one's mode of living could itself qualify as a category of Dada. One quintessentially Dada characteristic of Cravan's was his penchant for false identities (hotel thief, etc.). The movement's participants frequently invented aliases for themselves. In Berlin, Richard Huelsenbeck was known as 'World Dada', Raoul Hausmann was 'Dadasoph' and Johannes Baader was the self-styled 'Oberdada' (Super-dada). Baader, incidentally, cultivated his megalomaniac streak to a sublimely parodic pitch, vying with Cravan in terms of sheer bravado. In February 1919, having previously proclaimed

himself 'President of the Globe' in a Dadaist manifesto, he disrupted the inaugural meeting of the National Assembly at Weimar, demanding that the government be handed over to the Dadaists. Further afield, Max Ernst in Cologne became 'dadamax', while Duchamp, in New York, had himself photographed by Man Ray, dressed in fashionable women's clothes, as the enigmatic Rrose Sélavy, a deliberately artless pun, when pronounced in French, on the phrase 'eros c'est la vie'.

In developing alternative personae, the Dadaists implied that, rather than being fixed, identity is constantly in a state of flux. Implicitly they questioned the idea of an immutable core to the human personality or an intrinsic 'human nature', itself part of bourgeois ideology. This was extended further with Duchamp's gender slippages, so that the idea of sexual identity as something determined by biology was questioned. In terms of our discussion of the artist's 'image', this suggests that a secure or finite image was precisely something the Dadaists avoided; hence they admired the outrageous social posturing of a figure such as Cravan. As was revealed by the Berlin Dada Fair, they were ambivalent about the modern age's mania for publicity and spectacle, simultaneously endorsing and undercutting it.

Turning to the public personae of Surrealist artists, it is surprising, given the psychoanalytic preoccupations of the movement, that alternative identities were less widely adopted. Max Ernst's alter ego, the 'Bird Superior' Loplop was a notable exception. The artists generally favoured an outward show of conformism. This extended to a reassertion of late 19th-century dandyish codes of conduct, whereby excessive display was considered vulgar. Several leading Surrealists sported the dandyish attribute of the monocle (as did many Dadaists) while the Belgian painter Magritte notoriously suppressed any indication of his imaginative self by adopting the bowler hat and umbrella of the city gentleman. When the Surrealists did indulge their fascination for extravagant dress or disturbing mutations of identity, they often did so in the socially

acceptable context of high-class Costume Balls. There are some memorable photographs of Max Ernst, for instance, dressed as the aforementioned Loplop at an event in 1958. Salvador Dalí was the obvious exception to all this.

Dalí's flamboyant showmanship, emblematized by his famous upturned moustache, is notorious, but the Dalí phenomenon warrants further attention precisely because students of modernism find the artist's self-promotion so galling. Dalí posed difficulties for the Surrealists themselves, and was only fully in favour with André Breton from 1929 to 1934, after which relations between the two men cooled considerably. Dalí flouted all the ideological protocols of Surrealism; as the 1930s progressed, he advocated both monarchist and Fascist sentiments. He also cultivated an innate fondness for kitsch, developing a fascination for the more excessive flourishes of Art Nouveau – he wrote an innovative article in the Surrealist journal *Minotaure* in 1933 on the tendril-like ironwork of Hector Guimard's entrances to the Paris Metro. His garish, showily accomplished, paintings were designed from the outset to be anti-aesthetic. He described them as 'instantaneous colour photography done by hand of the superfine, extravagant . . . superpictorial, superplastic, deceptive, hypernormal, feeble images of concrete irrationality'.

Dalí's insistent self-obsessiveness, his love of the politically incorrect and the aesthetically recherché, can be seen as a deliberate decision to play the vulgarian in the eyes of André Breton. The Surrealist leader was to anagramatize his name as 'Avida Dollars', discerning in the later Dalí all of the commercial motivations that official Surrealism repudiated. However, as was suggested above, by the time of its late 1930s public exhibitions, Surrealism had, however uncomfortably, become wedded to capitalism, and Dalí simply admitted to the fact. The Surrealists were not coy either in recognizing Dalí's value as publicity; hence his presence in the 1938 show, at a time when he was officially losing favour with them. It took Dalí's genius for bad taste to draw out from George Orwell one

of the few considered mainstream literary responses to Surrealism of the 1930s. Deciding that Dalí was 'as anti-social as a flea' and his work 'diseased and disgusting' Orwell was nevertheless exercised by its ethical challenge as art. We might deduce from this that Dalí alone among the Surrealists fashioned a public image measuring up to Dada standards of irritability.

Disseminating Duchamp: Dada reviews

We have looked at how assiduously the Dadaists and Surrealists cultivated their images but how exactly did their reputations become established? After all, the audience for avant-garde art at that time was small. At the end of its five-year life, the number of subscribers for the first Surrealist journal, *La Révolution Surréaliste*, was only one thousand. The audience for Surrealism could not have been substantially larger.

In the case of Dalí, news of his larger-than-life activities travelled quickly: at the London International Exhibition of Surrealism of 1936, for instance, he wore a deep sea diver's outfit, attracting considerable attention. But reputations were often established by more insidious means. The name Duchamp is synonymous with some of the most iconoclastic works of Dada and Surrealism, yet the man himself was private and (deliberately) enigmatic. So how did the cult of Duchamp become established?

A brief account has been given of the rejection of Duchamp's urinal from the New York 'Independents' exhibition of April 1917. A month after that event a slim proto-Dada journal, titled *The Blind Man*, had appeared. It contained a photograph of the offending object and a short anonymously authored article responding, in mock outrage, to the urinal's rejection and defending it from an imputed charge of plagiarism:

> Whether Mr Mutt with his own hands made the fountain or not has
> no importance. HE CHOSE IT. He took an ordinary article of life,

placed it so that its useful significance disappeared under the new title and point of view – and created a new thought for that object.

We can be sure that Duchamp was behind this article – he probably got one of his female friends, Beatrice Wood, to write it – since it offers a philosophical justification for his 'readymades' (to be discussed further in Chapter 3). But the most pressing reason for the piece lay in manufacturing a controversy which would not otherwise have existed; the actual events surrounding the rejection of *Fountain* are hardly known. Even the original object seems to have disappeared at some point during the 'Independents' exhibition. If it has become a Dada icon it is as a result of the photograph in *The Blind Man*, taken by the modernist photographer Alfred Stieglitz (Figure 3), although, later in his life, Duchamp disconcertingly had 'replicas' produced.

All of this underlines the extent to which *Fountain* and its associated 'scandal' were stage-managed affairs. At the same time it brings into focus a theme which now deserves central prominence; the way in which Dada and Surrealist publications functioned.

The Blind Man was one of the earliest of a spate of journals published by the Dadaists in the movement's various locations. Possibly the most widely influential of these journals, and the longest running, was Francis Picabia's *391*, which he published intermittently from 1917 to 1924 from wherever he happened to be at the time: Barcelona, New York or Paris. Its name implied a kind of evolutionary progression from the American photographer Alfred Stieglitz's earlier magazine, *291*, whose title referred to the address of his gallery on Fifth Avenue, New York.

It was in *391*, in an issue of 1920, that Picabia further contributed to the dissemination of the Duchamp legend. He took Duchamp's anti-art provocation *L.H.O.O.Q*, the 'assisted readymade' of 1919 consisting of a print of the Mona Lisa with added moustache and beard, and replicated it (without the beard, which he appears to

have forgotten) in close proximity to a reproduction of a work by himself consisting of an ink splash and titled *Holy Virgin*. The notoriety of both works was thus assured. In October 1922, in the pages of another Dada magazine, this time *Littérature*, the organ of the Paris group, Duchamp's myth was consolidated by a key article on him by André Breton. Here Breton set in motion the concept of a cerebral Duchamp, more interested in making gestures than creating works of art, which would definitively secure his reputation among the nascent Surrealist group: 'Could it be that Marcel Duchamp reaches the *critical point* of ideas faster than anyone else?'

Clearly Duchamp's myth was built up as much via magazines and enigmatic photographs as via the exhibition of his relatively meagre output. He did not have a proper one-man show of his works until his retrospective of 1963. Even the reputation of his greatest work, *The Bride Stripped Bare by Her Bachelors, Even* was built up through appreciative descriptions and asides in Surrealist journals, notably Breton's essay 'Lighthouse of the Bride' published in *Minotaure* in 1934/5, rather than through people actually seeing the work. How Duchamp himself orchestrated the build-up of his reputation is a fascinating question but it can hardly be discussed here. Dada's publishing infrastructure clearly did much of the work for him. It is necessary now, however, to pursue the functioning of journals from a Dada to a Surrealist context in order to further explore continuities and differences between the movements. Journals were of even greater significance for Surrealism than for Dada. Similarly, if photography was crucial in disseminating Duchamp, as we saw in the case of *Fountain*, it became an absolutely central tool in the Surrealist publications.

Insulting priests in the street and other photo-opportunities: the Surrealist reviews

A copy of the Surrealist journal *La Révolution Surréaliste* of December 1926 contains a seemingly innocuous photograph of an

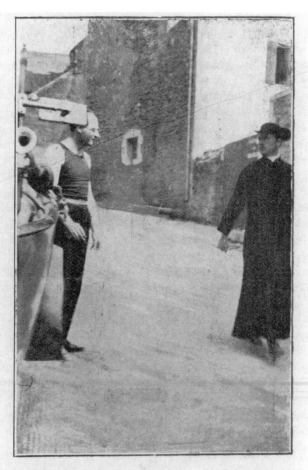

NOTRE COLLABORATEUR BENJAMIN PÉRET
INJURIANT UN PRÊTRE.

8. 'Our colleague Benjamin Péret in the act of insulting a priest',
photograph reproduced in *La Révolution Surréaliste*, 8 (Dec. 1926)

exchange between two figures, with the arresting caption 'Our colleague Benjamin Péret in the act of insulting a priest' printed beneath it (Figure 8).

The image appears to be a casual, deadpan photographic document but is surrounded by poems written by the Surrealist poet Benjamin Péret, one of which parodies the 'Chicago Eucharistic Congress', at which 'everyone rushes towards the divine excrements and the sacred spit'. Clearly the image, rather than being an incidental snapshot, constitutes an elaborate set-piece, its purpose being to reinforce the blasphemous message of the poem. In effect it records a kind of 'performance event'. Péret obviously had a friend at hand to photograph his act.

This is a good example of the way in which photography operated in Surrealist magazines. The principal reviews in question were *La Révolution Surréaliste* (1924–9), *Le Surréalisme au Service de la Révolution* (1930–3), and *Minotaure* (1933–9), although I shall also be referring throughout this book to *Documents* (1929–30), the organ of the renegade Surrealists who surrounded Georges Bataille. The kinds of photography these publications employed ranged from composed studio photographs taken by Surrealism's house photographers, Man Ray or J.-A. Boiffard, to ones simply appropriated from other sources. These images were placed in the context of scholarly articles, literary essays, accounts of dreams, and so forth, and frequently competed for attention with reproductions of Surrealist paintings. The layout of the magazines was much more sober than Dada journals such as Picabia's *391*, which experimented freely with typefaces. Indeed the model for *La Révolution Surréaliste* was *La Nature*, an earnest 19th-century scientific journal.

In using a 'dry' presentational style, which made items such as photographs appear like documents or items of evidence, the Surrealists declared their commitment to a project of enquiry, a systematic attempt to interrogate man's lot vis-à-vis the 'reality

9. Cover: *La Révolution Surréaliste*, 1 (1924)

principle'. The journals should thus be understood as the privileged sites of Surrealist ideology.

In the case of the Péret photograph, the image clearly related to the Surrealists' fervent anti-Catholicism. Many of them had been brought up according to the religion's precepts and, as well as opposing its moralism, they were appalled by the alliance in the

early 1920s between right-wing political parties and Catholic organizations in France, first under the 'Bloc National' government and then, from 1924, under a ruling alliance of Radicals and Socialists. Particularly galling for them was a pro-Catholic trend among French intellectuals in the mid-1920s, including figures such as Jean Cocteau. Their attitude to this tendency is registered in a photograph on the cover of the June 1926 issue of *La Révolution Surréaliste*. It shows a crowd of people looking skyward and is labelled 'The Latest Conversions'. The image had actually been appropriated from a then little-known, now famous, photographer, Eugène Atget, a specialist in documentary records of Paris, whom Man Ray had ' discovered' as an old man living near to him. Atget's picture, taken in 1912, had simply been a record of an eclipse, but the Surrealists, in typical fashion, reinvented the image with their own meanings.

Photography was clearly employed by the Surrealists to press home political or social messages. There is one particularly striking instance where an image was again appropriated, but not even from a known source; it consisted simply of two anonymous photographs of the Papin sisters, labelled 'Before' and 'After', which were republished in *Le Surréalisme au Service de la Révolution* in May 1933.

The Papin sisters had committed one of the grisliest and most sensational crimes to hit early 1930s France. A text in the same Surrealist journal, in a section dedicated to 'fait divers' or bizarre news items, told how these impeccably bourgeois young ladies, having been placed in service by their mother in a respectable Le Mans household, had developed a loathing for their employers and had ended up murdering them with ritualistic precision, tearing out their eyes and smashing their heads.

On one level the dual photograph of the sisters, which registered an extraordinary change in their physiognomies, corresponded to the Surrealist's fascination with 'convulsive beauty'; a kind of physical

AVANT

APRÈS

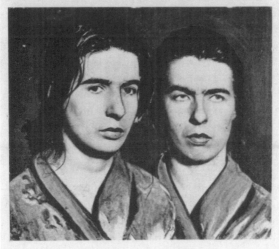

« Sorties tout armées d'un chant de Maldoror... » (Voir page 28).

10. 'The Papin Sisters: Before and After', from *Le Surréalisme au Service de la Révolution*, 5 (May 1933)

jolt in relation to extraordinary visual phenomena which will be discussed later. However, the Surrealists also sympathized with the violent response to servitude represented by the sisters' act. Believing that accepted morality often served to cover up ethical cowardice, the Surrealists had venerated criminals on other occasions. In the very first issue of *La Révolution Surréaliste*, for instance, they had placed photographic mug shots of themselves around a photograph of Germaine Berton, an anarchist who had assassinated Marius Plateau, leader of an ultra right-wing organization. Hence the image of the Papins evoked a whole range of Surrealist (as well as Dadaist) preoccupations centring on the relations between criminality and morality.

In using photographs, alongside texts, in their journals, the Surrealists set up a complex and ironic engagement with the issues of their day. This further reinforces the point that Surrealism, even more than Dada, was concerned as much with life, in its public and ethical dimensions, as with aesthetics. However, neither the Dadaists nor the Surrealists saw their social interests as confined solely to the 'official' dimension of public life. As shown by the Surrealists' interest in the Papins, or the Dadaists' parodic flirtation with commerce, there was a desire to engage with the entire spectrum of social knowledge and representations. Although most of the Dadaists and Surrealists came from middle-class backgrounds, they had a strong fascination for mass culture, or for what in France is known as the 'populaire.'

Popular pleasures

In one of the most insightful essays written on Surrealism the German Marxist writer Walter Benjamin posed the question: 'What form do you suppose a life would take that was determined at a decisive moment precisely by the street song last on everyone's lips?' In thus invoking the revolutionary potential of supposedly 'low' cultural materials, the critic was voicing a running theme in early 20th-century avant-gardism. Movements such as Cubism were

deeply interested in breaking down the distinction between 'high' and 'low' culture, as is shown, for instance, in the French painter Léger's introduction into Cubist painting of advertising motifs. The left-wing commitments of both Dada and Surrealism gave a particular inflection to their gestures of solidarity with the 'populaire', even though in the early 20th century mass culture was usually something manufactured for the people rather than arising from them. Benjamin understood their commitment to the poetics of the 'everyday' extremely well. Discussing André Breton's novel, *Nadja* (1928), an account of Breton's love affair with the woman of the title, he writes:

> Breton and Nadja are the lovers who convert everything that we have experienced on mournful railway journeys . . ., on Godforsaken Sunday afternoons in the proletarian quarters of the great cities, in the first glance through the rain-blurred window of a new apartment, into revolutionary experience. They bring the immense forces of 'atmosphere' concealed in these things to the point of explosion.

In this section and the next I want to draw out some of the ways in which the Surrealists and the Dadaists before them made their pact with the 'everyday'. In doing so, the discussion in this chapter will shift from the way Dada and Surrealism inserted their message into the social world to the degree to which that world saturates their productions and way of life.

Starting with Dada, there are plenty of examples of artists in particular using vernacular idioms to downplay the 'artiness' of their creations; thus Picabia's *Portrait of a Young American Girl in a State of Nudity* (Figure 11) employs the style of commercial graphics found in cheap ads or trade catalogues. I have talked already of the Dadaists parodying the commercial world, and this could be underlined by the fact that the word 'dada', quite apart from deriving from a dictionary (see Chapter 1) was used, just prior to Dada's emergence, by a Zurich company, Bergmann and Co, to

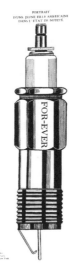

PORTRAIT
D'UNE JEUNE FILLE AMERICAINE
DANS L'ÉTAT DE NUDITÉ

FOR-EVER

11. Francis Picabia, 'Young American Girl in a State of Nudity', line drawing illustrated in *291*, 4/5 (July/Aug. 1915)

advertise beauty products. But the best way to demonstrate Dada's mimickry of mass culture is to look at a further example of a Dada journal, this time one produced by the Berlin group: *Jedermann sein eigner Fussball* (Everyman his own Football) of February 1919, with a cover bearing one of the earliest examples of Dada photomontage by John Heartfield.

Unlike other Berlin Dada journals, such as *Der Dada* where varied typefaces and multidirectional layouts were employed, the design here functions as a skit on conservative layout. Beyond this, as with Berlin Dada in general, it is crucial to appreciate the piece's political background. The journal, one of a sequence produced by the fervently Communist Heartfield–Herzfelde–Grosz faction of Berlin Dada, came out a few weeks after the Communist uprising in Berlin, led by the Sparticists Karl Liebknecht and Rosa Luxembourg, had been savagely crushed by the Free Corps under the orders of the Minister of Defence

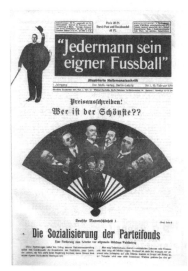

12. *Jedermann sein eigner Fussball* (**Everyman his own football**), **cover of journal, one-off issue (15 Feb. 1919)**

Gustav Noske. The cover cleverly attacks the new ruling Socialist (SPD) party, with the heads of its leading figures and propagandists, including Noske, arrayed around an open fan, with the words 'Prize Competition: Who is the Prettiest?' placed above them. This is a direct reference to the prize competitions for poster designs which were then placed in newspapers by political groups. It also pointedly precedes an article by Heartfield's brother, Wieland Herzfelde, in which he questions whether the election which the SPD had won could be considered democratic, given that its advertising had been financed by people with pro-SPD interests. All in all, then, the design both plays with mass advertising and criticizes its role in manufacturing political consent. The surreal photomontage of the bowler hatted man next to the journal's title – which is also by Heartfield – was incidentally a visual reinforcement of the title's exhortation not to allow oneself to be kicked around by others but to do it for oneself.

On balance, Heartfield's cover design could be said to criticize rather than affirm mass culture, in this case political advertising. Once again, this establishes a contrast between Dada and Surrealism since the Surrealists often cultivated a more openly celebratory attitude towards popular culture. This is typified by their attitude to *Fantômas*, the hugely popular French 'penny dreadful', published by Fayard from 1911 onwards. The fictional Fantômas, a perpetually elusive master criminal who committed blood-chilling murders under a variety of false identities, was venerated by the Surrealists for his enigmatic and lawless persona. On 3 November 1933 the Surrealist poet Robert Desnos read out his epic, 25-verse *Complainte de Fantômas* on French and Belgian radio, piling up lurid images, many of which derived from the covers of the Fantômas books: Fantômas, in top hat and tails, hovers malevolently over the rooftops of Paris; a human clapper swings from side to side inside a gigantic bell, blood and jewels pouring down from it . . . and so on. Similarly, the Belgian painter René Magritte, whose deliberately stilted painterly realism owed much to popular graphics (such as the covers of Nick Carter detective magazines), paid explicit homage to the 1913–14 film versions of *Fantômas* directed by Louis Feuillade. One of Magritte's most famous images, *The Murdered Assassin* (1927) is derived compositionally from a frame from one of these.

What impressed the Surrealists was the way in which the exploits of Fantômas conjured up a modern urban mythology, corresponding to the imaginative needs of thousands of Parisians. Fascinated by the unconscious life of mass culture, they embraced popular representations much more uncritically than the Dadaists. More than anything, though, it was the city in its own right which they mythologized. This important theme now warrants a fresh discussion.

The city

If we were searching for compelling images of the modern metropolis, George Grosz's paintings and graphics of the Berlin Dada period would be an obvious choice. Grosz, who had developed a bitterly pessimistic view of human nature while serving in the German army in 1914–15, depicted the city as a hellish vortex of unleashed forces. Writing in a letter about his painting *Dedicated to Oskar Panizza* (1917–18) he described 'A teeming multitude of possessed human beasts', adding: 'I am totally convinced that this epoch is sailing on down to its destruction – our sullied paradise . . . just think: wherever you step smells of shit.' In his brilliantly acerbic drawings, which appeared in Berlin Dada publications such as *Die Pleite* (Bankrupt!) or as lithographs in portfolios published by Wieland Herzfelde's publishing company Malik Verlag, Grosz depicted a Berlin dominated by those who had prospered and suffered through warfare: bloated profiteers and pitiful war cripples. Even Grosz's more tender works, such as the watercolour-cum-photomontage, *Daum Marries* (Figure 13), partly referring to his own marriage in 1920, evokes a Berlin of vice girls and automatons, with a glimpse of a faceless street in the background.

Grosz's Dada vision of Berlin is worlds away from Surrealist representations of Paris, a fact which is not surprising given the post-war situation in the two cities. For the Surrealists Paris was a city of revelation. Certain places acquired the character of avant-garde shrines. In 1921 the Paris Dadaists had embarked on bizarre excursions to unpromising locations such as the church of St Julien-le-Pauvre. As Surrealists they sought out particularly quirky or atmospheric sites. Possibly the most revered of such locations, the 'Ideal Palace' of the Postman Cheval, was actually some distance from Paris, in the village of Hauterives near Lyon, and thus necessitated a form of pilgrimage. Cheval had constructed his 'palace', a heavily encrusted and overgrown-looking structure – like Brighton Pavilion filtered through an opium trance – with unusual stones collected over 33 years during his rounds as a postman.

13. George Grosz, *Daum Marries her Pedantic Automaton 'George' in May 1920. John Heartfield is Very Glad of it*, pencil, pen, watercolour and collage, 1920

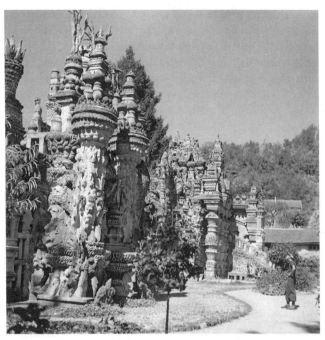

14. The 'Palais Idéal' of the Postman Cheval

The obsessive logic informing the 'palace', and the fact that its
builder had few conventional artistic pretensions, appealed
irresistibly to Surrealist sensibility. Paris itself offered a multiplicity
of further locations: the previously neglected museum housing
Gustave Moreau's weird Symbolist paintings; the hauntingly kitsch
Buttes-Chaumont park; the Tour Saint-Jacques connected to the
medieval Parisian alchemist Nicolas Flamel.

Such locations seemed to be part of an alternative city; one hidden
to tourists and miraculously spared by city planners, ruled by the
logic of unconscious desire rather than day-to-day utility. The two
great novels of early Surrealism, Breton's *Nadja* and Louis Aragon's
Paris Peasant (first serialized in 1924–5) both see their authors

wandering through a Paris understood to constitute a 'forest of indices' in Breton's terms; a network of cryptic signs and augurs of revelation. The Surrealists can be seen here as the natural heirs to the French poet Charles Baudelaire's conception of the modern artist as 'flâneur' or urban wanderer, committed to aestheticizing urban flux. In Aragon's *Paris Peasant*, which was created precisely in order to pinpoint a 'modern mythology', the author provides a detailed itinerary of Parisian spots which held a poetic resonance for him. Most famously, he revels in the down-at-heel atmosphere of the Passage de l'Opéra, an early 19th-century covered shopping arcade which was imminently to be demolished as part of the modernizing process set in motion under the Second Empire by Baron Haussmann. Describing its overall atmosphere as that of a 'human aquarium' Aragon lingers lovingly over various shop windows; that of a postage stamp dealer, a cane seller, a women's hairdresser. The latter provokes a stream of Surrealist fantasy as Aragon imagines the joys of an apprentice hairdresser whose life's work will consist of 'deciphering those networks which just a while ago gave a hint of sleep's disorder'.

The Surrealists systematically allowed the city to penetrate their psyches; indeed to map out their actions. By the early 1930s this was part of a self-consciously dialectical process, by which the interiority that had previously dominated Surrealist writing and art was set in counterpoint to the dictates of external reality. Everyday events that appeared merely to be the outcome of accident – such as apparently chance meetings on the street – were deemed to correspond to psychic necessity. This principle of 'objective chance' was central to certain early 1930s Surrealist productions such as Breton's novel *Communicating Vessels* (1932), and underpinned the 'encounters' with enigmatic and inherently significant 'found objects' which the Surrealists experienced on their regular visits to the Paris flea markets.

In many ways such ideas about how to negotiate the spaces of the city amount to a positive conception of modern experience which is

peculiar to Surrealism. However, it is worth noting that, following on from the insights of Walter Benjamin, writers such as Hal Foster have emphasized that, far from upholding a 'progressive' notion of modernity or modernization, the Surrealists' emphasis on the 'outmoded', as in their reclamation of sites such as the Passage de l'Opéra, could be seen as criticizing capitalism, in so far as the ruins from its past are brought back to haunt it. In this sense, despite their immersion in the city's matrix of signs, the Surrealists could be thought to be as scathing about the implications of the urban spectacle as, say, the Berlin Dadaists.

This chapter has located Dada and Surrealism in their world, showing how they seized on modern means of dissemination, and allowed 'modernity' to infiltrate their productions and lifestyles. The demands of life constantly outweighed those of art. But however much Dada and Surrealism downplayed art, their participants have become famous primarily as practitioners of it. It is time, therefore, to capitulate, and to turn to aesthetics.

Chapter 3
Art and anti-art

Discussing aesthetics, André Breton once noted that, from a Surrealist point of view, the way in which a picture was painted was virtually irrelevant. It was the mental reality that the picture 'looked onto' that was all-important.

The best way of appreciating the distinctiveness of Breton's attitude is by reference to the Modernist aesthetics of the critic Clement Greenberg, which dominated art criticism after Surrealism's demise in the late 1940s. Greenberg stressed disciplinary 'purity'. Far from opening onto some other reality, painting was required to draw attention to itself as an artistic discipline; to deal with problems intrinsic to painting. The rigours of this pursuit, Greenberg asserted, would lead to the attainment of degrees of formal, or aesthetic, resolution.

Disciplinary and formal purity were anathema to most of the practitioners of Dada and Surrealism. In their productions artistic disciplines constantly overlapped; the textual, the visual, and the performative were often in a state of free play. By the same token, formal 'beauty' seemed an irrelevant pursuit, given the world the artists were living in. They were ambivalent in any case about art as an institution, with the Dadaists often pledged to destroying it. In looking at Dada and Surrealist artistic and literary production in this chapter we must constantly bear in

mind this deep-seated ambivalence towards traditional art and aesthetic purity.

Greenberg certainly did his best to discredit what the Dadaists and Surrealists stood for. In an essay on Surrealism of 1945 he criticized what he considered to be its 'literary' basis. Although this attitude now seems somewhat dated, it is still remarkably tenacious. Surrealist artists such as Dalí or Magritte are frequently denigrated as 'literary' while Dada artists are often thought insufficiently serious due to their preoccupation with playful or humorous content. For Dada and Surrealist artists, however, this kind of critique would have completely missed the point of their work. They would have been proud to appear literary, having a particular commitment to the poetic. The word 'poetic' was generally understood by the Dadaists and Surrealists as 19th-century Romantic writers and artists would have understood it, in terms of a 'state of soul' or mode of sensibility rather than a form of practice. All in all, the best way of understanding Dada and Surrealist aesthetics is not via traditional notions of beauty but via this notion of a poetic 'attitude'.

Given the primacy of poetry, language, or rather the linguistic sign, continually underlies the work of Dadaist and Surrealist practitioners. This will be evident in much that follows. My primary aim, however, is to establish a series of distinctive differences in terms of the technical and procedural means by which participants in the two movements attained their poetic outcomes. Dadaist utilization of chance will be played off against Surrealist uses of 'automatism'. Dadaist techniques such as collage and photomontage will be pitted against Surrealist techniques such as painting and photography, The Dadaist readymade will be contrasted with the Surrealist object, and so on. The obvious place to begin, though, is with poetry itself.

Poetics

Broadly speaking, Dadaist poetics can be split between approaches prevalent in Germany and Switzerland and ones prevalent in France. In the 'Cabaret Voltaire' section of Chapter 2 I looked at Hugo Ball's attempt in Zurich to return to the 'alchemy of the word' via his phonetic poetry. Implicit in this was a rejection of language's semiotic capacities, its ability to convey meaning. Ball's return to the basic units of language probably owed something to his awareness of Russian futurist poetry with its emphasis on the autonomous characteristics of language. However, rather than being fully 'abstract' in spirit, a description which better describes the phonetic poetry of the Berlin Dadaist Raoul Hausmann, Ball's poetry often communicates a mystical desire to find new names or words for things. In his diary he wrote: 'Why can't a tree be called Pluplusch or Pluplubasch when it has been raining?' In this respect, he partly responds to the German philosopher Nietzsche – a major influence on artists of Ball's generation – who had written of his sense of a mismatch between words and the things to which they refer, seeing language as a 'mobile army of metaphors' which had become worn out. Other German Dadaist poets reveal a similar despair with language's signifying capabilities. In Hanover, Kurt Schwitters produced his own variants of phonetic poetry, intimately related to his so-called 'Merz' abstractions in collage, but also produced texts in which different orders of language coexist, destroying any overall sense of coherence. Part of one poem reads:

> Greetings, 260 thousand ccm.
> I thine,
> thou mine,
> we me.
> And sun unboundedness stars brighten up.
> Sorrow sorrows dew.
> O woe you me!
> Official notices:
> 5000 marks reward!

By contrast, French Dadaist poetry – notably that of the Paris Dadaists surrounding the journal *Littérature* – could be said to be more compliant with semantic conventions although similarly committed to the irrational. This was partly because figures such as André Breton and Paul Eluard had more straightforwardly 'literary' sources in, for instance, the French Symbolist poetry of Rimbaud or Paul Roux, the self-styled Saint-Pol-Roux. We will see in the next section that 'automatic writing' was their main technical innovation, but what unified them more than anything was a conception of the poetic image. This would prove central to the Surrealist aesthetics they developed from 1924 onwards.

The Surrealist attitude to the image hinged on the principle of the meeting of incompatible realties. Breton was to see the French Cubist poet Pierre Reverdy as the main theoretical exponent of the device, but examples of its use could be found in many of Surrealism's literary precursors, one example being Rimbaud whose 'A Season in Hell' of 1873 described hallucinatory visions such as 'a drawing room at the bottom of a lake'.

In full-blown Surrealist poetry we are bombarded with striking images, such as Eluard's 'the earth blue as an orange' or the impassioned litany in Breton's 'Free Union' (1931):

> My wife with her figure of an otter between the tiger's teeth . . . My wife with temples the slate of a hothouse roof
> With eyebrows the edge of a swallow's nest . . . My wife with wooden eyes always under the axe . . .

Other Surrealist poems characteristically combine startling juxtapositions of imagery with anarchic humour. Part of a work by Benjamin Péret reads:

> And the stars that frighten the red fish
> are neither for sale or rent
> for to tell the truth they are not really stars but apricot pies
> that have left the bakery.

What was constantly sought was a glimpse of 'the marvellous'. Again and again Breton invoked the electrical metaphor of a spark to evoke the inspirational jolt produced as unrelated images collided.

Clearly French Dada – and subsequently Surrealism – was committed to a more lyrical poetics than German/Swiss Dada, where there was a more thoroughgoing anti-Romantic deconstruction of language. There are important exceptions to this: Hans Arp, who would leave Zurich for Paris and Surrealism, often produced poems revealing a lyricism rooted in German Romanticism. It has been asserted by critics that deconstructive Dadaist poetry merely reflects chaos whereas Surrealism, by compromising with traditional poetic idioms, achieves more lasting results. Certainly poetry such as Eluard's now appears to have great formal elegance. But Dadaist sound poems, such as Schwitters's seminal 'Ur Sonata' of 1922–32, are far from chaotic in terms of their abstract internal structures. They also possessed an afterlife, in terms of the development of concrete poetry and performance aesthetics in post-1945 European art, that was possibly more significant than that of Surrealist poetry, which often bred mannerism and cliché.

The disjunctive nature of Dada poetry is in keeping with the relativist philosophies espoused by its writers. In his 1918 'Dada Manifesto' Tristan Tzara asserted that 'a work of art is never beautiful, by decree, objectively, for everyone'. The Surrealists also distrusted normative ideas of beauty, but André Breton would theorize the Surrealist image, both in its verbal and visual registers, in terms of a notion of 'Convulsive Beauty' in his philosophical-cum-autobiographical disquisition *Mad Love* (1937). Resolutely avoiding the criteria of traditional aesthetics, not least because he was implicitly straddling literature and the visual arts, Breton talked of the experience of beauty as approximating to a form of physical convulsion, with a strong erotic undertow. Rather obscurely, he defined three types of Surrealist 'convulsive beauty': 'veiled erotic', which characteristically arose from the merging

of the animate and inanimate (as in coral), 'fixed–explosive', which came about when motion was translated into repose (as in a photograph of a locomotive overgrown with vegetation) and 'magical–circumstantial', which arose from a 'magical encounter' with a seemingly portentous phrase or object.

This attempt to produce new aesthetic categories, which in any event seems partial, says a great deal about the difference between Dada and Surrealism. For the Dadaists there could be no normative aesthetic experience. Art itself was open to question. The Surrealists by contrast nurtured a lingering utopian longing for a transformed and experientially transforming poetics/aesthetics.

Automatism versus chance

Poetry underpinned Dada and Surrealist aesthetics, but how exactly was the poetic language of these movements generated? Where did it come from? For the Surrealists in particular there was one clear answer: the unconscious. In his *First Surrealist Manifesto* of 1924, André Breton described how, whilst falling asleep one evening in 1919, a phrase had occurred to him as though 'knocking at the window'. Before long, Breton was making use of such spontaneously occurring material for poetic purposes and, along with the poet Philippe Soupault, published the first fully 'automatic' proto-Surrealist text, *The Magnetic Fields*, in 1920. Automatism was predicated on the conviction that the speed of writing is equivalent to the speed of thought. Writing rapidly with no preconceived subject in mind, the poet became, in Breton's terms, a 'modest recording device'.

By 1922, as part of the so-called 'mouvement flou' when Paris Dada gradually metamorphosed into Surrealism, Breton and his friends experimented with more dramatic means of bypassing conscious control. For a period one or other of them would willingly enter into a hypnotic trance and respond to questions from the rest of the group. The poet Robert Desnos was particularly susceptible to these

states and on one occasion responded unnervingly to questions about the poet Benjamin Péret:

> Q. What do you know about Péret?
> A. He will die in a crowded car.
> Q. Will he be killed?
> A. Yes.
> Q. By whom?
> A. (He draws a train, with a man falling from its door.) By an animal.
> Q. By what animal?
> A. A blue ribbon my sweet vagabond.

Eventually the trances threatened to get out of control, with the poet René Crevel one time attempting to lead a group suicide, and they were abandoned. Automatism increasingly came to be seen as a response to discoveries in psychiatry and psychoanalysis. Breton's original exposure to these disciplines had been in 1916 when he had practised Freudian techniques of free association on shell-shocked troops during his military service as a medical orderly. However, it was not so much Freud who provided a model for automatism as the French psychiatrist Pierre Janet whose *L'Automatisme psychologique* of 1889 had reported extensively on the outpourings of patients undergoing hypnosis. Janet, however, had tended to downplay the creative volition of his patients, and by 1924, when Breton made automatism the pre-eminent Surrealist technique in the *First Manifesto*, it was Freudian free association which was given prominence.

Surrealist automatism was predicated on the suppression of rational consciousness. It should be stressed, however, that it was not always used in the creation of Surrealist writing; much of the Surrealist poetry cited in the last section only made partial use of it. Nor should it be assumed that it was entirely an invention of Surrealism; the earlier Dada poetry of Picabia, Tzara, Arp, and Schwitters had often arisen from similar processes, although Arp saw the body as much as the mind as its wellspring: 'Automatic

poetry issues straight from the entrails of the poet or from any other organ that has stored up reserves . . . It crows, curses, stammers, yodels, just as it pleases.' It could be argued that automatism was routinely employed by the Dadaists and simply theorized in psychoanalytic terms by the Surrealists at a later date. Indeed, if we now turn to the ways in which the Dadaists, particularly, in Zurich, had understood the abandoning of creative control, not so much in favour of automatism but more in conformity with chance, some significant distinctions between Dadaist and Surrealist aesthetic attitudes can be established.

Around 1916–17 Arp, the principal visual artist of Zurich Dada, had produced a series of abstract works in collaboration with his partner Sophie Taeuber in which squares of paper were collaged in precise grids onto sheets of paper. As visual abstractions these works participated in the beginnings of a widespread phase in European art at that time involving figures such as Mondrian and Kandinsky. More distinctively 'Dada', however, were a few collages which Arp produced in direct counterpoint to these highly precise works. In these Arp randomly dropped pieces of paper onto mounts and fixed them where they landed (Figure 15). He claimed later that they were produced 'according to the laws of chance'.

Slightly earlier, Marcel Duchamp, who was then in Paris but was shortly to move to New York and to his own version of Dada, had done something comparable. Commencing work on *The Bride Stripped Bare by her Bachelors, Even*, his *magnum opus* in glass which was to end up as a diagrammatic depiction of frustrated desire, opposing a group of mechanistic 'Bachelors' at the bottom to a 'Bride' at the top, he had dropped three pieces of threads and had 'fixed' the configurations in which they fell, producing templates from them which served as variations on a standard measure. He had then used these 'Standard Stoppages' (as he called them) to help determine the placement of the Bachelors in the *Large Glass*, implying that his work conformed to an alternative, irrational set of physical laws to those of external reality.

15. Hans Arp, *Rectangles Arranged According to the Laws of Chance*, collage, 1916/17, Museum of Modern Art, New York

Both Arp and Duchamp were departing radically from the model of authorial control synonymous with art-making at that time. They were also pioneering a characteristically 'Dada' attitude which stands at the foundations of a tradition of aleatory art in the 20th century, incorporating figures such as the composer John Cage. More significantly for our current discussion, both artists were invoking impersonal or nature-based processes as opposed to psychologically orientated human ones, albeit ironically in Duchamp's case. Arp had an essentially mystical understanding of what he was doing. Chance for him was linked to nature and was part of an 'unfathomable raison d'être . . . an order inaccessible in its totality'. Whereas the Surrealists were primarily interested in the individual psyche, the Dadaists chose to invoke forces which were entirely independent of themselves. They distrusted human egotism and a too-high valuation of human reason; a world war had arisen from such values. They had little respect either for Freud's systematization of the irrational. Tristan Tzara described psychoanalysis as a 'dangerous disease' which lulls our 'antireal inclinations' to sleep and helps perpetuate bourgeois society. The Dadaists distrusted Freud for wishing to tame the unconscious rather than allowing it free play in the service of social critique. They therefore distrusted the Freudian basis of Surrealist automatism, although it should be emphasized that the Surrealists valued Freud for plumbing unconscious mechanisms rather than 'curing' the maladies they gave rise to.

In showing how the Dadaist understanding of chance conflicts with the Surrealist understanding of automatism, our reference points have necessarily shifted from poetic to visual ones. This is consistent with the constant cross-overs between literary and visual aesthetics in Dada and Surrealism mentioned earlier. If we turn now to the visual art of Surrealism, it is interesting to see that, while verbal automatism found an equivalent in the technical innovations of certain artists, Dadaist chance was also subtly incorporated into Surrealist procedures.

16. André Masson, *Birth of Birds*, automatic drawing, *c.*1925, Museum of Modern Art, New York

In 1924–5 the French painter André Masson, attempting to find a visual equivalent for the automatism called for by Breton in the *First Surrealist Manifesto*, produced an important sequence of 'automatic drawings'. In them, a set of intensely personal images – eroticized bodies, animals and architectural elements – were poetically fused together as he drew rapidly without premeditation.

These elevated 'doodles' might initially appear abstract, but the Surrealists never took the step into complete abstraction that we saw in Arp. Given some effort, Masson's *Birth of Birds* of 1925 thus reads comparatively straightforwardly as a woman's body, with birds emerging from the vulva.

Slightly later than Masson, the German-born artist Max Ernst, who had recently moved to Paris from Cologne, similarly reacted to the *Manifesto* with his 'frottages' of 1925. Here, the artist placed sheets of paper over raised surfaces, such as wood-graining, and made rubbings. He then allowed forms to suggest themselves, blocking out or re-emphasizing parts of the images to conjure up a personalized flora and fauna. Ernst published these as reproductions in a portfolio titled *Histoire Naturelle*. It is interesting that Ernst, who had once been part of the Dada movement, reveals a much greater degree of passivity in his working process than Masson. He thus looks back to the impersonal principle of chance as it had been understood within Dada, although his direct inspiration was none other than Leonardo da Vinci who, in his *Treatise on Painting*, had recommended that artists should use formless blots as inspirational triggers for compositions.

Ernst cleverly harnessed Dadaist chance to Surrealist automatism, making it answerable to the imperatives of the unconscious. His case reveals how Surrealist aesthetics often subtly reverted back to Dada. The Surrealists would devise many other ways of psychologizing chance; they actually lived their lives according to principles of 'objective chance' as discussed in the previous chapter. But one wonders whether, in the final analysis, they did not end up civilizing or domesticating what, in Dada, had been an essentially anarchic non-human principle.

Collage versus painting

Staying with the visual art of Dada and Surrealism, it is worth establishing some further differences between the movements in

their approaches to artistic media and technique. An initial contrast can be set up by returning to Max Ernst, who bridged the two movements in any case, and to the transition he made from a Dadaist use of collage to a distinctively Surrealist mode of painting.

In 1921, at the invitation of the Paris Dadaists, who had been aware of his activities in Cologne, Ernst had an exhibition of his collages at the *Au Sans Pareil* gallery in Paris. It was a revelation for the Parisians. If Breton's and Soupault's *The Magnetic Fields* had foreshadowed textual Surrealism, this exhibition effectively pre-empted visual Surrealism. Ernst would shortly join the group and produce work, such as the 'frottages' just mentioned, which conformed to their theories.

So what was so significant about Ernst's Dada collages? Collage was already well established as an avant-garde technique at this time. Bits of linoleum, wallpaper, and so on had been introduced into their paintings by Picasso and Braque around 1912–14 in the so-called 'Synthetic' phase of Cubism, largely to reintroduce witty allusions to the real world into their increasingly abstracted paintings. Ernst, however, assembled his collages from fragments of recognizable imagery, juxtaposing fragments of encyclopedia plates, commercial catalogues, anatomical treatises and photographs to produce disturbing counter-realities. In *Santa Conversazione* of 1921, for instance, illustrations of birds and cuttings from anatomical diagrams were shunted into an alliance with photographs in a semi-illusionistic pictorial space. Alluding in its title to religious iconography – namely the traditional theme of Madonna and Child with Saints – *Santa Conversazione* blasphemously invokes the Virgin Birth by depicting a dove perched on the basin-like 'womb' of the main figure.

Once he had moved to Paris, at the height of the 'mouvement flou', Ernst set about translating collage into painterly terms. In 1919 he had been profoundly impressed by illustrations of works by the Italian painter Giorgio de Chirico. During a fertile period in Paris

17. Max Ernst, *Santa Conversazione*, collage, 1921

during 1911–15, De Chirico had developed a 'metaphysical' mode of painting in which he envisioned lonely late-afternoon Italian piazzas flooded with unearthly light, the statues casting long, melancholy shadows. The 'faux naif' style in which Chirico painted these visions, involving the use of dizzily receding perspectives and the diligent cordoning off of flatly painted forms with fine black lines, provided Ernst with the painterly vocabulary with which to re-embody the startling juxtapositions of his collages. Under De Chirico's influence, the semi-illusionistic indications in certain of the collages blossomed into suggestions of a palpable psychic universe. The series of paintings Ernst produced between 1922 and 1924, including *Oedipus Rex*, *Of This Men Shall Know Nothing*, and *Pietà* (Figure 4) became keystones of visual Surrealism.

Arguably, though, in being translated into the terms of Surrealist painting, Dada collage underwent a process analogous to that which Dadaist chance had undergone in being annexed to automatism. Employed by Ernst in Cologne, collage had summoned up a world that was profoundly inimical to human control; whole systems of ideas and regimes of representation appeared to be in conflict. But when Breton wrote of Ernst's collage in the catalogue of the 1921 *Au Sans Pareil* exhibition, he linked the technique to proto-Surrealist poetics, employing his favoured metaphor of the spark generated by the meeting of separate realities to underline Ernst's effects. When Ernst embarked on his fully 'Surrealist' paintings in the early 1920s, partly under the patronage of Breton, he returned to a technique – namely oil painting – which had virtually been proscribed by the Dadaists for its connotations of élitism and tradition.

Photomontage versus painting

This sense of a watering down of Dada principles can be reinforced by comparing another Dadaist technique, photomontage, with Surrealist painting. Photomontage was the pre-eminent visual

innovation of Berlin Dada. Both factions in Berlin, the Hausmann–Höch faction and the Grosz–Herzfelde–Heartfield faction, claimed to have 'discovered' it, but such squabbles need not detain us here. It is important, however, to briefly differentiate the photomontages of the Berlin group from Ernst's photocollages as described in the last section. Ernst rarely made overt social references. His works suggested irrational collisions of ideas or thought systems, and, to this end, he played down the physical nature of his materials, rephotographing his collages to create a seamless effect. By contrast, Berlin photomontage was profoundly politicized, the very act of cutting up and recombining imagery from newspapers and magazines bearing connotations of cutting into the fabric of social reality. Berlin photomontage made the physical process of constructing the image – the fragmentary nature of the pieces of imagery, their inconsistencies in terms of photographic scale, etc. – manifest in the final work. This can be seen in Hannah Höch's *Bourgeois Wedding Couple – Quarrel* of 1919 where the humorous content of the image, a parody of bourgeois marriage in which an infantilized couple in sports gear undergo their private traumas among the latest household gadgets, is subordinated to the sense that these are still cut-out fragments of printed matter.

Turning to Surrealist painting, it is obvious that, as an 'autographic' technique, in other words one where the very marks made by the artist's brush speak of his or her 'touch', painting could hardly be said to signify social interaction or exchange in the manner of Berlin photomontage. Whereas Hausmann in Berlin once talked of his fellow artists as 'photomonteurs', fitting their pictures together like construction workers, Surrealist painting spoke by contrast of individual reverie and of the artist-genius. It intrinsically lacked Dada's political edge.

Surrealist painting was distrusted to some degree from within the movement itself. In 1925 Breton described it as a 'lamentable expedient', and it was to be up to the artists themselves to

18. Hannah Höch, *Bourgeois Wedding Couple – Quarrel*, photomontage, 1919

convince him of its applications. Almost from its beginning it was polarized. On the one hand, there was a veristic mode of painting, in which irrational alternative realities were depicted with pseudo-academic exactitude. This tendency was rooted in Giorgio De Chirico but also in French 19th-century Symbolist painters such as Odilon Redon and Gustave Moreau. It tends, for convenience sake, to be dubbed 'dream painting', although, as will be shown later, examples of it by Ernst and Dalí did not necessarily make use of personal dreams but often plundered Freudian case histories.

On the other hand, there was the 'automatic' painting, characterized by the spontaneous production of painterly marks or blotches to suggest forms, practised by artists such as André Masson, whose related 'automatic drawings' were mentioned earlier. This technique could claim to be more truly 'Surrealist' in terms of Breton's theorizing.

19. Joan Miró, *The Hunter*, oil on canvas, 1924, Museum of Modern Art, New York

Along with Masson, Joan Miró is a key figure within this 'automatic' tendency. Having moved from his native Catalonia to Paris in 1920–1, he initially developed a highly idiosyncratic pictographic language in works such as *The Hunter* (1923–4) (Figure 19). To the upper left of this work, the 'hunter' of the title is depicted as a stick-man, his alertness signalled by his enormously enlarged ear and his heart which is shown to be 'on fire'. At the base of the canvas is his quarry; a peculiar sardine-cum-rabbit. Miró's entire oeuvre would subsequently be characterized by this kind of capricious poetic transformation, with visual signs undergoing continual metamorphosis from one painting to the next. Automatism, which he used from the mid-1920s – sometimes in the planning of works, or sometimes, as in the important *The Birth of the World* (1925), as part of the finished result – perfectly suited his fluid working methods.

As suggested already, painting had a torrid time at the hands of Surrealism's theorists. Just after the *First Manifesto* the writer Max Morise wrote an essay entitled *The Enchanted Gaze* which expressed doubts about 'dream painting'. Such works, according to Morise, were incapable of expressing the temporal or unfolding nature of dreams. Film, as we will see, was better equipped to do this. The 'secondary revision' involved in producing them also put a brake on the unconscious. In April 1926 Pierre Naville – at this time editor of the Surrealist journal *La Révolution Surréaliste* – declared more dramatically 'Everybody knows there is no Surrealist painting.' Even painterly automatism was placed under suspicion since aesthetic habits, such as a sense of compositional balance, potentially got in the way of complete spontaneity.

Breton rose to painting's defence and wrote a series of essays and catalogue introductions in the later 1920s, poetically championing such artists as the French painter Yves Tanguy whose dream landscapes, populated with strange biomorphic forms, he particularly admired. But Breton never fully established a theoretical justification for Surrealist painting; hence the pointed

title these collected writings were eventually given: *Surrealism and Painting*. Breton was convinced of the importance of Surrealist precursors such as De Chirico or Picasso. The latter in particular was courted unsuccessfully by him over a long period, and the licence accorded to sexual and violent fantasies by Surrealism undoubtedly reinvigorated Picasso's output of the 1920s and 1930s. But Breton was to vacillate in his support of the likes of Miró and Masson. His perennial point of criticism, in line with the increasingly Marxist commitments of Surrealism, was that painters succumbed too easily to the seductions of their 'métier' and too quickly took advantage of the commercial benefits offered to them. The comparatively academic technique of a relative latecomer to Surrealism, the Belgian painter René Magritte, might have led to such compromises, but the literalism with which Magritte's best works present hallucinatory phenomena or philosophical conundrums gives them a distinctly uncompromising edge (Figure 20). On the other hand, the technical facility of Salvador Dalí, who made a dramatic entry into the Paris group from his native Catalonia in 1929, would confirm all of Breton's fears.

Dalí's early Surrealist paintings – such as *The Lugubrious Game* and *The Great Masturbator* of 1929 – were genuinely inventive, their 'ultra-retrograde' technique, in Breton's phrase, being entirely appropriate for the realization of the host of psycho-pathological fantasies, often culled from literary sources such as Freud or the late 19th-century 'sexologist' Richard von Kraft-Ebbing, with which they swarmed. In the early 1930s Dalí also did much to shore up the theoretical resources of visual Surrealism, inventing his so-called 'paranoiac-critical method'. He demonstrated this in a short contribution to the journal *Le Surréalisme au Service de la Révolution* in 1931, reproducing a postcard of a group of Africans sitting in front of a straw hut, which, when turned sideways, reads as a phantom head (Figure 21). Just as clinical paranoia involves the obsessional reinterpretation of external phenomena, so Dalí filled his 1930s canvases with skilfully

20. René Magritte, *Le Viol* (The Rape), oil on canvas, 1934

contrived double-images; thereby, in his own terms, 'discrediting reality'. Ultimately, though, such devices inclined towards mannerism, and as Dalí inevitably attracted wealthy patrons, such as the English collector Edward James, so his inventiveness slackened. He became the 'Avida Dollars' of Breton's famous anagram.

COMMUNICATION : Visage paranoïaque.

A la suite d'une étude, au cours de laquelle m'avait obsédé une longue réflexion sur les visages de Picasso et particulièrement ceux de l'époque nègre, je cherche une adresse dans un tas de papiers et suis soudain frappé par la reproduction d'un visage que je crois de Picasso, visage absolument inconnu.

Tout à coup, ce visage s'efface et je me rends compte de l'illusion (?). L'analyse de l'image paranoïaque en question me vaut de retrouver, par une interprétation symbolique, toutes les idées qui avaient précédé la vision du visage.

André Breton avait interprété ce visage comme étant celui de Sade, ce qui correspondait à une toute particulière préoccupation de Breton quant à Sade.

Dans les cheveux du visage en question Breton voyait une perruque poudrée, alors que moi je voyais un fragment de toile non peinte, comme il est fréquent dans le style picassien.

Salvador DALI

21. Salvador Dalí, 'Paranoiac Face', page layout from *Le Surréalisme au Service de la Révolution*, 3 (Dec. 1931)

Painting ends up as Surrealism's Achilles heel. It had two major flaws; in its automatist form it was compromised by its very aesthetic preconditions; at its most academically realist it could be seen as allied to bourgeois taste. Arguably, the ponderously 'surreal' scenarios of, say, the French artist Pierre Roy, or the Belgian Paul Delvaux, amount to little more than academicism.

Photography

If painting failed to match Surrealist aspirations, it is worth opposing its fortunes to those of 'straight photography' (as opposed to photomontage). In this book I have tended to employ photography, as the Surrealists themselves did, as much to document their opinions as to foreground its own status as an art form, but it could easily be asserted that it constituted the Surrealist medium par excellence. The very fact that photography is a mechanical medium meant that it constituted a 'modest recording device', to recall Breton's description of the Surrealist poets, which was uniquely qualified to automatically transcribe the surreality embedded in reality. It is important to recall that Breton's ideal, in the *Second Manifesto of Surrealism*, was always a fusion of the real and the surreal, by contrast to Dalí who sought, as he himself said, to 'systematize confusion'.

Photography is inherently surreal. As Susan Sontag has said, 'Surrealism lies at the heart of the photographic enterprise: in the very creation of a duplicate world, of a reality in the second degree, narrower but more dramatic than the one perceived by natural vision.' A camera will often pick up uncanny details completely by chance, making us aware of the strangeness of the familiar. The Surrealists themselves certainly capitalized on this. Breton, for instance, asked the photographer J.-A. Boiffard to produce photographs of seemingly humdrum Parisian locations for his novel *Nadja*. As noted earlier, this was an account of a love affair in which the emotions of the lovers, to say nothing of Nadja's incipient insanity, distil chance revelations from the everyday.

Surrealism undoubtedly had its share of staged 'artistic' photography. Pre-eminent were the contrived studio set-ups of the ex-New York Dadaist Man Ray who had gravitated to Paris, like Max Ernst, at the very moment of the formation of Surrealism. Man Ray brought his formidable studio skills to bear on seductive, classically composed, and highly fetishistic images of the female body (Figure 26). Photographic manipulation was also widely practised. Man Ray is again of central importance with his 'Rayographs', in which objects were placed on photographic paper in the darkroom and the whole ensemble exposed, so that ghostly 'negative' shapes were left behind, and 'Solarizations', in which the darkroom light was briefly turned on during the developing process, causing a halo of light to surround the contours of the photographed images.

Photographic manipulation also extended to processes such as double exposure and the overlaying or combining of negatives to produce internally riven and 'doubled' images. Such processes, as carried out by Man Ray or by the French photographer Maurice Tabard, have been seen by the American art historian Rosalind Krauss to be peculiarly suited to Surrealism. They seem to suggest that the reality which the mechanical nature of photography ostensibly records is inherently unstable: merely a collection of movable signs, like a text; a point which might remind us again of the poetic basis of Dada/Surrealist aesthetics. However, Krauss's argument notwithstanding, it is perhaps when photography is at its least self-consciously 'arty', as suggested earlier, that it is most genuinely surreal. If Surrealist painting looks a little conformist in comparison with Dadaist collage and photomontage, photography emerges as an eminently 'automatist' surrealist medium. Whereas Surrealist painting had a comparatively disappointing legacy, at least in the European countries where it grew up, producing legions of imitators but few heirs, some of the central figures of mid-20th-century photography – Henri Cartier-Bresson, Brassaï, Bill Brandt, and André Kertesz – were decisively affected by Surrealism.

The readymade versus the object

Painting may suffer in comparison to photography within Surrealism, but at least it survived. By contrast, sculpture in the traditional sense played a modest role in both Dada and Surrealism, and a new genre of three-dimensional production usurped its place: that of the object. The historical starting point here is Marcel Duchamp and his readymades. The most notorious of these, *Fountain*, produced in New York in 1917, has already been discussed, but it was not the first of the pre-manufactured (hence 'readymade') objects which Duchamp appropriated as his own. That item was the *Bicycle Wheel* of 1913, produced in Paris just before Duchamp's move to America, and actually a combination of two objects: the wheel and fork of a bicycle, and a wooden stool. The wheel and fork have been inserted upside down into the stool to produce a movable 'sculpture' on a 'pedestal'.

It is clear from the above that sculptural terminology is appropriate, albeit ironically, to *Bicycle Wheel*. The object subtly parodies traditional sculpture in so far as it contests the hierarchical split between base and sculptural object; the stool is just as much a utilitarian object as the wheel and there is thus an equality between the work's structural elements. Duchamp has freed the objects from art's hierarchies and ironically re-aestheticized them at the same time. This use of real objects to replace sculpted forms certainly represented a massive challenge to convention, although Picasso had incorporated oilcloth and a rope in his *Still Life with Chair Caning* of 1912. As with the photomontage of the Berlin Dadaists there was an attempt to purge art of its familiar materials and to engage materially with the world of industrialized mass production.

Possibly the most important challenge posed by the *Bicycle Wheel* was at the level of authorship. Like the sequence of readymades by Duchamp that followed it, it raises a fundamental question about the very nature of art. If, as Duchamp once noted, art,

etymologically speaking, means 'to make', Duchamp has exonerated himself completely from that obligation.

It was not until 1917, and the publication of a photograph of *Fountain* (Figure 3), that Duchamp turned the readymade into a conceptual provocation. Prior to this objects had been chosen almost as private 'philosophical toys'. As with *Bicycle Wheel*, the readymades were not necessarily single objects. By the early 1920s, possibly registering the literary preoccupations of the nascent Paris Dada group, Duchamp was producing elaborately poetic 'assisted readymades' such as *Fresh Widow* (1920), a down-scaled pair of French windows with squares of shiny black leather in place of its panes of glass. The interaction between title and object is crucial here, reminding us again of the verbal basis for Dada/Surrealist aesthetics. Spoken aloud, both words of the title *Fresh Widow* suppress the letter 'n', provoking a free-wheeling range of associations including sadomasochism. Man Ray, at that time one of Duchamp's New York Dada accomplices, shared his friend's black humour. His *Gift* of 1921 consisted of a flat iron with a row of tacks sticking out aggressively from its base. Dada assemblages such as these acquired a legendary status among the Paris Surrealists.

In 1924 the Surrealist leader Breton wrote an important essay entitled *Introduction to the Discourse on the Paucity of Reality*. In it he discussed an enigmatic book encountered during a dream:

> The back of the book was formed by a wooden gnome whose white beard, clipped in the Assyrian manner, reached to his feet. The statue was of ordinary thickness, but did not prevent me from turning the pages which were of heavy black cloth.

His conviction that such objects should be put into circulation to 'discredit' the 'creatures and things of "reason"' heralded the production, within Surrealism, of 'symbolically functioning objects'. However, this phase of activity had to wait until 1931.

Its immediate catalyst was a sculpture by the Swiss artist Alberto Giacometti, the one traditional sculptor within the Surrealist orbit, who had settled in Paris in 1922. His *Untitled (Suspended Ball)* of 1930–1, an enigmatic construction in which a sphere of plaster hung within a cage-like structure, a groove in its lower circumference skimming the sharp edge of a plaster crescent placed directly beneath it, had an enormous impact on the Surrealist group when a photograph of it was published in *Le Surréalisme au Service de la Révolution*. Breton, in particular, extolled its aura of unfulfilled desire.

The wave of object-production that followed this group revelation generated some of the most arresting works of visual Surrealism. Dalí surpassed himself with an elaborately fetishistic ensemble which he described as follows:

> A woman's shoe, inside which a glass of milk has been placed, in the middle of a paste ductile in form and excremental in colour. The mechanism consists of plunging a sugar lump on which an image of a shoe has been painted, in order to watch the sugar lump and consequently the image of the shoe breaking up in the milk.

After a time the group produced less complicated objects. *Fur Breakfast*, a cup and saucer lined in fur by the Swiss-born artist Meret Oppenheim – one of the few women to play a prominent role in this phase of Surrealism – is possibly the most famous of these and was the main attraction at the key exhibition of Surrealist objects at Charles Ratton's Paris gallery in 1936. But *Fur Breakfast* has become over-familiar. Another important piece by Oppenheim is *My Nurse*. This work also makes use of notoriously fetishistic items, namely shoes. It would be interesting to speculate on the different ways in which Dalí and Oppenheim use them, with the proviso that, much as Oppenheim's assemblage appears to speak to the contrary, psychologists have generally been unwilling to acknowledge the existence of female fetishism. Oppenheim once observed that the shoes evoked for her the idea of 'thighs squeezed

22. Meret Oppenheim, *My Nurse*, metal platter, shoes, string, and paper, 1936

together in pleasure', in belated recognition of the 'sensual atmosphere' which her childhood nurse had exuded. Possibly she is ironizing the whole issue of female fetishism here. Female fetishism, if it exists, would be predicated on the psychological function of fetishism for men, which is normally assumed to be heterosexual in basis. Dalí's object certainly upholds this. Surely there is more than a hint of a lesbian fantasy in Oppenheim's comment. One could easily see the trussed-up shoes, which double as a turkey on a platter, as constituting some form of bondage fantasy on the part of the artist.

If, returning to a contrast between Dada and Surrealism, we further compare Oppenheim's *My Nurse* with a Duchamp readymade such as *Fountain* (Figure 3), it is apparent that Oppenheim's Surrealist object openly insists on its psychological content while the Dada readymade mutely awaits our interpretation. *Fountain* has in fact been interpreted as a bi-gendered form, with its curves and the hole

at the base giving a 'feminine' inflection to an otherwise 'masculine' receptacle. If the readymade might, ironically, be thought usable, were it not temporarily being designated as 'art', the Surrealist object proffers its own uselessness as something of potential value. Georges Bataille, who was a major critic of Surrealism's romanticizing tendencies in the 1920s and 1930s, once derided the impotence of aesthetics, declaring ' I challenge any art lover to love a canvas as much as a fetishist loves a shoe.' In this context *My Nurse* could be seen as serving precisely the needs of fetishism rather than those of art.

This comparison establishes a clear division between Dadaist and Surrealist aesthetics. The readymade serves to collapse the distinction between art and non-art. It implicitly acknowledges that art is something to be contested on its own terms. By contrast, the Surrealist object complies with art's conventions, however altered these may have become, in order to fulfil a new experiential function.

Nothing more powerfully illustrates the catalytic role envisaged for the Surrealist object than an incident famously recounted by André Breton in *Mad Love* (1937). Breton talks of how Alberto Giacometti had been facing an apparent psychological block in finishing the head of a sculpture, later to be called *The Invisible Object*. He and Breton had gone for one of their familiar Surrealist trawls of the Paris flea markets and had found themselves drawn inexplicably towards a peculiar metal half-mask which they were later to identify as a fencing mask. Giacometti later realized that the form of the object provided a solution as to how to complete the head of his sculpture. Here Breton is not so much talking of the Surrealist object as something that is closer to the Duchampian readymade, namely the 'objet trouvé' – the 'found object' which corresponds mysteriously to the dictates of 'objective chance'. His point is that Giacometti's unconscious desires had effectively predisposed him to finding the object. Breton would see romantic love functioning in an analogous manner. But the task of the Surrealist object was, in a

sense, to render such a search unnecessary and to speak directly to our desires. Theoretically at least it serves to move us beyond aesthetics entirely.

Film

While the Dadaists sought to discredit or to redefine art, ironically creating new art forms (such as the readymade) in the process, the Surrealists paid less attention to artistic media as such, convinced that poetic content would render issues of form irrelevant. They sought a merging of art into life in the distinctively 'avant-garde' terms defined at the start of Chapter 1.

A way of emphasizing this distinction is to turn finally to the ways in which the movements made use of film. As a medium which had only come into being in 1895–6, when the Lumière brothers demonstrated their invention, film was the most unequivocally 'modern' of any of the media they employed. The Dada films that were made by Hans Richter and Viking Eggeling in Zurich or René Clair and Man Ray in Paris, or the Surrealist films of Dalí and Buñuel, were part of a massive wave of film experimentation in the early decades of the 20th century that drew heavily on the achievements of avant-garde art movements.

Dadaist film is characterized precisely by a self-consciousness about its material nature as film and a concern with forcing its audience to appreciate this fact. The German-born Richter and the Swedish-born Eggeling, who were comparatively late and relatively peripheral members of the Zurich Dada group, worked collaboratively to pioneer abstract film during 1919–21. Eggeling, who was to die in 1925, laboriously produced one major work, his *Diagonal Symphony* in which abstract forms evoked musical patterns and notation. Richter's work similarly responded to music, but was more inventive visually. In his *Rhythmus 23* (1923), for instance, a series of rectangular shapes merge together and split from one another, expanding and receding in the process.

As with the internal divisions of Dada in general, the abstracting tendencies of the Zurich-based filmmakers, which would eventually lead them into an alliance with International Constructivism, contrast with the greater emphasis on anti-bourgeois content in the Dada films produced in Paris. Possibly the most significant of these, René Clair's *Entr'acte* of 1924, makes use of narrative conventions, but its storyline is hardly 'continuous' in the manner of contemporaneous Hollywood silent films. The narrative effects of Clair's film are constantly disrupted by dramatically angled shots, superimposed images and slowed-down or speeded-up cinematography. Montage editing, a technique involving the dramatic juxtaposition of shots to create strong emotional or intellectual effects in the viewer, is also employed, but not in the doctrinaire fashion of contemporaneous Russian ideologues of film such as Serge Eisenstein. Clair's formal cinematographic concerns were constantly held in check by his collaborator, Francis Picabia. At this time Paris Dada had become completely exhausted and Breton was in the process of launching Surrealism. The ex-Dadaist Picabia's contribution to the film was therefore to intersperse Clair's more overtly experimental sections with slapstick sequences redolent of full-blown Dada irreverence. For instance, a lengthy semi-abstract sequence, in which the billowing skirts of a pirouetting ballet dancer are intercut with images such as the geometrical lines of buildings, ends when the dancer is revealed to be a bearded man.

Man Ray had also made a five-minute Dada film in Paris the previous year. His *Return to Reason* was more formally restrained than Clair and Picabia's *Entr'acte*, but no less anarchic. The artist scattered objects such as pins and thumbtacks on the celluloid and then exposed it in the manner of his photographic 'rayographs'. These strips worked in counterpoint with others in which objects such as the torso of a woman and a merry-go-round were shown slowly rotating.

All of the above Dada films resist any straightforward imaginative

entry by the spectator. A different logic underlies the small group of Surrealist films produced between 1927 and 1930 by two pairs of collaborators: the French dramatist and poet Antonin Artaud and filmmaker Germaine Dulac, on the one hand, and the Spanish artist Salvador Dalí and filmmaker Luis Buñuel, on the other. In these, elements of narration and an emphasis on the emotions of the actors actively solicit the psychological involvement of the audience, although this is still frequently upset by dislocating or shocking images or by rapid montage editing, influenced as much by Buster Keaton in Buñuel's case as by avant-garde precedents. The Artaud/ Dulac film *The Seashell and the Clergyman* of 1927, a Freudian study of the Oedipal rivalry between an older and a younger man for an enigmatic woman, was the first Surrealist film, strictly speaking, but its more gentle 'poetic' ambience was to be overshadowed by the visual pyrotechnics of the Dalí/Buñuel collaborations.

The first of these, the 17-minute *Un Chien Andalou* (An Andalusian Dog), was shot in one week in March 1929, just before Dalí joined the Surrealists. The opening sequence, which is notorious, shows a man (Buñuel himself) sharpening a razor next to a window. As he observes a wisp of cloud passing across the moon, he slices open the eye of a woman sitting passively next to him (an ox's eye in actual fact) (Figure 23).

This remarkable prologue has been interpreted in various ways. The blinding could be seen as a metaphorical assault on the audience's vision and, by extension, an assault on cinematic conventions as such – the 'cutting' of a film could well be indicated. But the image has also been interpreted by film historians such as Linda Williams in Freudian terms as a symbolic displacement of castration anxiety. Buñuel himself once said that the only way of interpreting the film would be psychoanalytically, and Williams builds up a convincing case by referring to other sequences in the film where the male hero's castration anxiety is evoked via mutilated body parts. In one of these we move, via a dramatic series of disorientating close-ups, from an image of a hand trapped by a door – with a stigmata-like

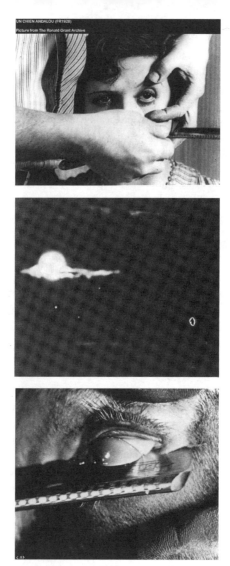

23. **Luis Buñuel and Salvador Dalí**, frames from *Un Chien Andalou*, film, 1929

wound in its palm pouring forth ants – to an image of a woman, seen from above, poking a severed hand with a stick.

If the dream-like images of *Un Chien Andalou* beg to be unpacked psychoanalytically, the second Dalí/Buñuel film, *L'Âge d'Or* (The Golden Age) of 1930, deals more squarely with the real world, although its images are no less shocking. Its central concern, in committedly Surrealist fashion, is the social repression of desire, particularly as an outcome of Catholic dogma. Its climax consists of a lengthy intertitle announcing the imminent emergence from the Selliny Castle of the libertines who have engaged in the Marquis de Sade's *120 Days of Sodom*. As the castle door opens we see that the first of the sodomites is Jesus Christ.

If Dadaist film drew attention to itself as film, usually with subversive intent, Surrealist film aimed to make the viewer forgetful of the medium, in order to 'transform consciousness'. Dada's legacy in terms of film history was an avant-garde or 'underground' tradition which reached fruition in the experimental films of 1950s and 1960s filmmakers such as Stan Brackhage or Andy Warhol. Surrealism, on the other hand, would have greater impact on mainstream film where the audience is characteristically primed for imaginative release. Buñuel himself had an extremely fertile later career, producing important films ranging from *The Exterminating Angel* (1962) to *The Discreet Charm of the Bourgeoisie* (1972), while key international filmmakers have continued to extend the Surrealist possibilities of the medium to the present day. Important figures here are the Czech film animator Jan Švankmajer and the American David Lynch whose *Mulholland Drive* (2001) demonstrates the extent to which lavish Hollywood production values powerfully enhance Surrealist effects. These are self-consciously 'Surrealist' practitioners, but mainstream film in general, with its thirst for ever more startling juxtapositions of imagery, has effortlessly absorbed the techniques of Surrealism.

The historical destiny of Dada and Surrealist film makes a broader

point about the aesthetics of the movements. In Surrealism there was a tendency to allow the filmic medium to function 'transparently', in other words, not to intrude too insistently on the spectator's aesthetic expectations, in order to effect a psychic transformation. This was easier for mass culture to assimilate than Dada's insistence on the disruption and negation of the spectator's pleasure. In this respect one could point to the enormous impact Surrealism has had on graphic design and advertising right up to the present day. Numerous instances could be cited, but the series of playfully surreal Benson and Hedges cigarette advertisements of the 1970s are excellent examples. Critics such as Fredric Jameson have noted that the Surrealist cult of desire, along with the visual techniques fostered to give it expression, has been hijacked by the market system to cater to the 'pseudosatisfactions' of capitalist consumerism. In a sense this returns us to a question posed in the introduction, about our inability to have any real distance from the aesthetic consequences of Surrealism. It might be tempting to speak resignedly here of the way two committedly left-wing art movements, to drag Dada into complicity with Surrealism, failed to resist assimilation into capitalism. But that would be to foreclose matters before we have properly considered Dada and Surrealism's wider cultural and political aspirations. These, as we will see, were profoundly inimical to capitalist values. They are also the most fitting lenses through which to view their art.

Chapter 4
'Who am I?': mind/spirit/body

'How can anyone hope to order the chaos that constitutes that infinite, formless variation: man?' So asked Tristan Tzara in his 1918 Dada Manifesto. By contrast, André Breton began his Surrealist novel *Nadja* with the more hopeful but essentially troubling question 'Who am I?' Questions of identity, of the nature of consciousness or the relations between mind and body, were fundamental to Dada and Surrealism and fundamental also to disagreements between them. I want next to examine how such questions interconnected in their writings and art, and how they focus some of the more interesting debates among the theorists and artists concerned. If both movements espoused the pre-eminence of the irrational over the rational, how did they conceive of the irrational? If irrationalism was to be pursued, how did this contravene traditional humanist values, and to what degree was an anti-humanist programme desirable? Both Dada and Surrealism were opposed to conventional religion, mainly because many of their adherents had received stiflingly moralistic upbringings, but how could they undercut the mind–body dualism which is endemic to Western thought?

Their alternatives, as we will see, drew on various philosophical systems and modes of belief, often linked to mystical or hermetic thought. Opposing Judaeo-Christian distrust of the flesh, they were also drawn to a celebratory view of the bodily and the erotic.

97

Inevitably such views carried their own ideological baggage, and this will emerge as an issue during the discussion.

Irrationalism: for and against Freud

Tristan Tzara's 1918 Dada Manifesto declares: 'Logic is always false. It draws the superficial threads of concepts and words towards illusory conclusions and centres.' Convinced that any totalizing system of thought is in essence partial, Tzara, like the Dadaists in general, prefers to opt for a position of thoroughgoing relativism:

> If I shout:
> Ideal, Ideal, Ideal,
> Knowledge, Knowledge, Knowledge,
> Boomboom, Boomboom, Boomboom
> I have recorded fairly accurately Progress, Law, Morals . . . in order, finally, to say that . . . everyone has danced according to his own personal boomboom . . .

This relativism is partly ascribable to the influence of the German philosopher Nietszche, who affected nearly all of the major Dada theorists. Nietzsche's sense of human nature as something which is governed by irrational, essentially egotistical impulses was a common reference point for them, as was the thought of the French philosopher Henri Bergson who, in books like *Creative Evolution* (1907), had stressed the primacy of intuition in comprehending the nature of reality. Another common enthusiasm was the French poet Rimbaud, whose *Lettre du voyant* of 1871 had advocated 'a long, systematic derangement of all the senses' in order to turn the modern poet into a 'seer'.

Beyond these figureheads, it is helpful to draw a distinction between German and French Dadaist sources for irrationalist doctrine. Nietzsche's and Bergson's thought provided an overall psychologistic orientation, but it was Freudianism which most

decisively asserted the irrational basis for human motivation in the early years of the 20th century, emphasizing the internally riven nature of human psychology and the formative importance of sexuality in human development. Freud was certainly read by members of the German Dada groups fairly early on (*The Interpretation of Dreams* originally appeared in German in 1900), but, as noted earlier, they were generally suspicious of the 'bourgeois' tenor of his thought, feeling that his therapeutic goals served to adjust man to his social position. Max Ernst in Cologne was a major exception to this rule, but the Berlin Dadaists in particular tended to be more sympathetic towards left-inclined 'anti-Freud Freudians' such as the writer Otto Gross. As Richard Sheppard has shown, Gross's psychological critique of the over-valuation of rationalism and the dangerous repression of irrational components of the personality was much more conducive to the Berliners in the face of daily street violence. It also helped them to focus their opposition to the effete rhetoric of *Geist* upheld by left-wing Expressionist writers, such as Ludwig Rubiner, in the face of ruptures in the German Left. By the same token, the ideas of Freud's colleague Alfred Adler, who saw human beings as motivated by a Nietzschean 'will to power' and felt that a too-high valuation of the masculine principle lay at the heart of the modern malaise, were much more suited to the Dadaists in Berlin with their hard-nosed acceptance of the coexistence of destructive and affirmative impulses in human nature.

In Paris, by contrast, the climate was more propitious for orthodox Freudianism. I have discussed Freud's take-up by the Paris Dadaists, establishing that Breton had been introduced to his ideas as part of his medical training (Louis Aragon's initiation was virtually identical) and that Freud symbolically presided over the *First Surrealist Manifesto*. Freud was certainly more attractive to Breton than Nietzsche, not least because, as the 1920s progressed, Nietzsche's emphasis on the individualistic 'will to power' sat uneasily next to Breton's growing Marxist commitments. However,

Freud's importance for early Surrealism should not be over-emphasized. Breton mainly knew Freud via explanatory digests by the French psychologists Emmanuel Régis and Angelo Hesnard and was better versed in French neurologists such as Joseph Babinski. Freud's works were only gradually translated into French, *The Psychopathology of Everyday Life* being one of the first to appear in 1922. A strong case could be made for Max Ernst's entry into Surrealism in that year as being the catalyst for in-depth knowledge of the details of Freud's case studies. Ernst had read Freud as early as 1911 when he studied psychology as part of his degree at the University of Bonn. In 1922–3, as a Surrealist, he was to paint several important works drawing on this knowledge. *Pietà or Revolution by Night* (Figure 4), with its alternative title annexing the revolutionary project of Surrealism to Freud's emphasis on dreams, is a case in point.

But why the 'Pietà' allusion? In traditional Christian iconography a 'Pietà' is a depiction of the Virgin Mary bearing the dead Christ in her arms. Here, however, we appear to have a form of reverse Pietà with a father, rather than a mother, depicted holding his son. From various clues, notably his moustache, the 'father' in the picture can in fact be identified as Ernst's own father Philippe. On one occasion in Ernst's childhood, Philippe, who was an extremely pious Catholic teacher as well as an amateur painter, had painted his son as the Infant Jesus, and from this we can assume that the figure he is holding represents Max Ernst/Christ. Given the reverse Pietà logic, the image of Philippe would thus blasphemously evoke God the Father. Given that the son has been petrified, with his face and hands painted grey, the implication is that the father has turned his son to stone.

All of this strongly suggests that Ernst took the basic mechanisms of the Freudian 'dream work' – particularly the processes of 'displacement' and 'condensation' by which a dreamer's repressed desires and anxieties are encoded in the 'manifest content' of the dream – as a means by which he could supply himself with an

exotic psychobiography, scrambling elements of his own biography and aspects of Christian iconography together. His overall point of reference appears to be the central plank of Freud's account of childhood sexuality, the Oedipus Complex, which is predicated on the male child's unconscious fantasy of rivalry with the father for the mother's love, and the violent (castrative) retribution which would result. The 'latent content' of the painting would thus be that the father has taken revenge for the son's infringement of the incest taboo. Ernst, of course, was not reconstructing one of his own dreams but producing a form of self-analysis.

We should be wary, however, of too quickly reaching a finite interpretation. It is just as easy to read the Pietà as dealing with an 'inverted Oedipus Complex', which would involve a proto-homosexual attachment to the father, and in other Ernst paintings of the period, such as *Of This Men Shall Know Nothing*, further esoteric reference points such as alchemy worked in counterpoint to psychoanalysis. Although art historians have made efforts to see Freudian themes such as 'the uncanny' as all-pervasive within Surrealism, an artist such as Ernst was probably being far more ironic about Freudianism than such earnest interpretative schemas suggest. Ernst's Freudianism certainly set a precedent for the other Surrealists, but, possibly with the exception of Dalí, they rarely played Freud by the book. The 1930 French translation of the psychoanalyst's *Jokes and their Relation to the Unconscious* may, for instance, have chimed in with the Surrealists' fascination in that period with black humour but in 1928 Louis Aragon had been openly satirical about Freud being fashionable in France, claiming in his book *Treatise on Style* that the sentimental 19th-century novel *Paul and Virginia* 'would pass for an astonishing new work today, provided that Virginia made a few comments about bananas and Paul absentmindedly yanked out a molar now and then'. Freud in turn was sceptical about Surrealism. Asked by Breton in 1937 to contribute to an anthology of dream accounts, he refused on the grounds that the straight transcription of a dream without the

associations of the patient would be meaningless for him. The Surrealists' poetic interests were far removed from the actual concerns of psychoanalysis.

A broader question would be the overall status of the unconscious as a model for the Surrealists. What did it say about human nature in general? The notion of the unconscious presupposes that man is governed by an internal 'other'. To a degree the Surrealists romanticized this notion of a labyrinthine, potentially conflicted, inner self. In the tradition of Romanticism proper, they developed a cult of insanity. Breton was an avid collector of works by psychotic artists such as Joseph Crépin and Hector Hyppolite, and Ernst again galvanized visual Surrealism by famously bringing a copy of Hans Prinzhorn's book *The Artistry of the Mentally Ill* to Paris in 1922 as a gift for his friend Paul Eluard. In 1930, in a collaborative text entitled *The Possessions*, Breton and Eluard attempted to simulate states of psychosis. However, the Surrealists coped badly with insanity when it came too close. Little was done actively to help Nadja, the muse of Breton's first novel, after she succumbed to the insanity whose 'poetic' early signs had captivated him. Similarly Breton seems to have been deeply unnerved by the case of Antonin Artaud. This incendiary poet and subsequent theorist of the 'Theatre of Cruelty' had briefly been placed in charge of a short-lived 'Bureau of Surrealist Research' in 1925 but he and Breton fell out as it became clear that Artaud's and Breton's conception of revolution differed profoundly. For Breton revolution was essentially an intellectual position. For Artaud it demanded a visceral, soul-wrenching submission to unreason. When he eventually became insane, Breton offered little support.

If they proved unequal to the risks of an actual immersion in the unconscious, the Surrealists' theoretical engagement with it meant they were well placed to carry out a dissection of bourgeois mores, particularly with regards to sexuality. How far they were able to overcome their own bourgeois assumptions in doing this will concern us as we continue. But we would probably have to concur

with the Dadaists in asserting that social adaptation of a kind ultimately underlay Breton's understanding of the unconscious. As the place where desires are attained, in dialectical counterpoint to the insufficiencies of daily existence, the unconscious for Breton was an avenue onto a qualitatively transformed experience of life. At the same time Breton felt that everyday life should be transformed on a Marxist model. From the point of view of many Dadaists, his faith in a new dialectical contract between the conscious and the unconscious was underpinned by a rather suspect humanism. By contrast the Dadaists advocated anti-humanist attitudes.

Anti-humanism

One of the central themes of Dada in Berlin and New York was man-as-machine. Feeling that mankind had definitively thrown in its lot with mechanization, Dadaist artists in both cities developed a highly sophisticated iconography of 'mechanomorphs', human-machine hybrids. In Berlin in May 1920, George Grosz produced his *Daum marries . . .* (Figure 13) which alluded to his own recent marriage. Depicting his new wife Daum (a play on her nickname Maud) to the left, and himself, as an automaton, to the right, Grosz's picture, according to Wieland Herzfelde, amounted to an attack on marriage as a bourgeois institution. Marriage, according to Herzfelde, 'unfailingly transforms the man into a constituent part of itself, into a small cog within a larger system of wheels and gears' so that, whilst the woman is partly set free, the man 'addresses other sober, pedantic and calculating tasks'. This verdict may be laced with misogyny, but it reveals the extent to which the Dadaists understood mechanization to be all-pervasive. Interestingly the iconography of marriage was widespread in Dada. In 1919 another Berlin Dadaist Hannah Höch had produced a feminine take on the theme, depicting a couple shackled by modern gadgetry (Figure 18). In New York at that time Marcel Duchamp was laboriously working on his definitive statement on the man-machine conjunction, *The Bride Stripped Bare by her Bachelors, Even*. As noted previously, this

complex work on glass opposes a 'Bride' floating above to her earthbound 'Bachelors' below. Both the bride and her spouses are depicted as machines. As with Herzfelde's interpretation of Grosz, the Bride retains some autonomy, while the Bachelors are seen as masturbatory husks.

Whatever attitudes to marriage are involved here, it is evident that romantic love, in Duchamp's work in particular, is reduced to a mechanical operation. The human body is posited as a machine which has no natural relation with the soul or mind. On one level we could see the ghost of the French philosopher Descartes lurking behind all of this. Cartesian dualism, which formed the basic philosophical premise for modern scientific method, notoriously asserted that mind, as a thinking substance, is disembodied, leaving the body to be considered, by the likes of La Mettrie, purely as a mechanism. It could be, then, that the Dadaists were upholding the Cartesian viewpoint, although tinged with an intense irony. Duchamp's New York Dada ally, Francis Picabia, for instance, produced some extremely cynical responses to sexuality, *Portrait of a Young American Girl in a State of Nudity* of 1915 (Figure 11) equating female sexual availability with the operations of a spark plug.

Most of Picabia's work of this period speaks of an essentially anti-humanist distrust of spirituality and deep inward feeling. To some extent his attitudes were shared by the Berlin Dadaists. Raoul Hausmann, for example, asserted that 'Dada is the full absence of what is called Geist (Spirit). Why have Geist in a world that runs on mechanically?' But it is important to realize that it was the Expressionists' rhetoric of the struggle of modern man's soul with the machine that was the real butt of Hausmann's critique. In fact the Berlin Dadaists generally had a more positive conception of the machine than the New York group, perceiving a mechanical aesthetic to be a means of undermining individualism and advocating collectivity. They sought a robust materialism and shunned humanist platitudes, but, apart perhaps from Grosz, they

by no means upheld mind–body dualism in the way that the New Yorkers, however satirically, appeared to do. As we shall see later, the German-speaking Dadaists, in Zurich as well as Berlin, often leaned towards a mystically tinged monist philosophical attitude, whereby dualities like body and soul were brought into a paradoxical unity. In this respect they might have agreed with André Breton's conception of Surrealism had his thought not been so heavily impregnated with idealism. But what exactly does 'idealism' mean here? Let us turn back to Surrealism.

In the *Second Surrealist Manifesto* of 1929 Breton famously asserted: 'Everything tends to make us believe there exists a certain point of the mind at which life and death, the real and the imagined, past and future . . . cease to be perceived as contradictions.' This quotation partly helps to add meaning to the 'Sur' of 'Surrealism' in terms of its transcendental tone, but it is most interesting as an indicator of Breton's fundamental commitment to Hegelian dialectics. Breton had been introduced to the early 19th-century German philosopher's thought around 1912, and later admitted that he had largely 'intuited' its meaning. Fundamentally Hegel was instrumental for Breton in reconciling his early emphasis on the exploration of the unconscious with the commitment to change in the material world that came with his, and Surrealism's, allegiance to Communism after 1926. It was the idealist cast of Hegel's thought that was most crucial. In Hegel's elaborately abstract philosophy, mind or spirit comes to know itself via a progressive series of dialectical syntheses. For Breton the Surrealist image similarly operates via the collision of contradictory terms to produce a new, 'higher' unity.

Breton was an idealist in that he advocated the self-realization of the mind in its dialectical relationship with matter, but did this also add up to the kind of covert liberal humanism that many Dadaists would have found objectionable? The answer to this comes not so much from the Dadaists themselves but from Breton's most incisive intellectual combatant, Georges Bataille.

As noted earlier, Bataille was never part of the Surrealist group, but rather its interlocutor and scourge. After Breton had expelled various members of the group in 1929 – notably Michel Leiris, André Masson and Robert Desnos – several of them transferred their allegiance to Bataille's journal *Documents*. In many ways *Documents*, which ran from 1929 to 1930, had a similar 'scientific' aura to the Surrealist journals, but its quasi-academic articles concentrated more closely on issues such as ethnology and archaeology, offset against jazz and other aspects of popular culture. Most importantly, given the current discussion, an attack was mounted from its pages, in Bataille's writings in particular, on the idealist presuppositions of Breton's thinking. At times this is allegorical rather than direct. In the much-cited essay *Big Toe*, the big toe is said to be the part of man's constitution which separates him from the anthropoid ape. It is also that part which enables man to stand upright, with his mind on higher things. But, Bataille argues, man considers the toe, which is 'stuck in the mud', to be something base and ignoble. Feet, he asserts, are only adequately valued by fetishists. Bataille therefore seeks a reversal of values which, in other writings, will constitute a call for the celebration of the base or excremental aspects of human nature as opposed to the evasions of idealism.

More than anything Bataille sees Breton's conception of Surrealism as being bound to concepts of 'taste' and aesthetic beauty, despite the claims made in the *First Surrealist Manifesto* regarding the dethroning of conventional morality. In an essay titled *The Deviations of Nature* published in *Documents*, 2 (1930) Bataille dwelt on mankind's fascination with 'freaks' of nature such as Siamese twins. This text can in fact be read as a veiled commentary on the humanist emblem of the androgyne; the fusion of male and female beings common in the alchemical allegories to which the Bretonian Surrealists, as we shall see, were drawn. Alluding, though indirectly, to the androgyne as a yet further instance of an idealist synthesis, Bataille dwells on natural occurrences where the conjunction of two human beings does not produce something ideal

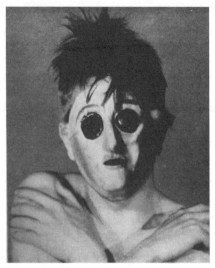

24. J.-A. Boiffard, *Carnival Mask*, photograph reproduced in *Documents*, 2 (Paris, 1930)

but something monstrous. Throughout *Documents* we find a constant play on the monstrous as a means of countering the ideal with blunt materiality. For instance, as illustrations to an article on masks by Georges Limbour, which asserts that the only Western equivalents for the ritual power of tribal Oceanic masks are items such as gas masks, there is a remarkable suite of photographs of carnival masks by J.-A. Boiffard. Presumably redolent of gaiety, one of them initially appears to have had its eyes burned out.

In 1929 there was a direct clash between Breton and Bataille when Breton lent on Surrealism's latest recruit, Salvador Dalí, to refuse permission for Bataille to reproduce his key painting of that year *The Lugubrious Game* alongside an exegesis of it written by Bataille for *Documents*. Bataille had to be content with a schematic diagram of the picture, but his commentary, which dwelt on the anxieties about masturbation and castration informing Dalí's painting, reveal the extent to which Dalí, with his self-avowed obsessions with

onanism, scatology, and putrefaction, was the exemplary Bataillean artist. Breton seems to have turned a blind eye to the truly 'convulsive' aspects of Dalí's work, although he was not slow, around the same period, to take objection to the unsublimated nature of Antonin Artaud's Surrealism. Although Dalí might legitimately have been claimed by Bataille, he remained, for the time being, in the Breton camp. Other artists would choose to desert Breton more or less definitively. One of these was André Masson whose leaning towards Nietzschean thought and violent imagery, in works such as the 'Massacre' drawings of 1933 in which men are depicted slaughtering women, was too much for Breton.

Bataille's anti-humanist critique of Breton might appear to resonate with the Dada critique of Surrealism's 'Pope' but Bataille's position was not identical with Dada. In his later years Bataille would actually appear much closer to Surrealism than he had in the heady 1920s, mainly because he endorsed their overall perception that part of modern man's dilemma consists in the absence of myth, or what he termed 'the sacred', to deal with the darker, anarchic impulses of human nature. When, with the coming of war in 1939, Dada and Surrealism could be seen retrospectively as bracketing two world wars, the need to deconstruct the idea of humanist Man became ever more urgent for their intellectual heirs, and Bataille's legacy was taken up by the likes of the French post-Structuralist thinker Michel Foucault. But Bataille's own anti-humanism hardly presented a 'solution'. There was even a period in the 1930s when it led him close to Fascism. Another way in which both Dada and Surrealism attempted to bypass both humanist values and mind–body dualism was via mystical or hermetic thought.

The mystical and the hermetic

'The *dada* hovered above the face of the waters before God created the world, and when he spake: let there be light! lo there was not light, but *dada*.' This joint proclamation by members of the Berlin Dada group reflects Dada's parodic attitude to conventional

religion. We have already discussed examples of virulent anti-Catholicism on the part of the Surrealists. What the Surrealists, like the Dadaists, particularly abhorred was the Judaeo-Christian split between soul and body. Although Duchamp and Picabia, as we have seen, used the language of dualism to satirize modern man's technologism, the Dadaists in particular invoked pre-Socratic or non-Western philosophical principles, in which the spiritual and the material were held in equilibrium. This was part of a larger critique of the modern psyche.

The sources the Dadaists drew on here were very diverse. In Zurich Hugo Ball was particularly attracted to the Greek Pre-Socratic thinker Heraclitus, who had stressed that everything is in perpetual flux, while Hans Arp was drawn to Christian mystics such as the 17th-century German writer Jacob Boehme, and Chinese Taoist philosophers such as Lao Tzu. We know that Arp read out passages from Boehme at one of the 'Dada Soirées' in Zurich in 1917, significantly choosing sections which stress the importance of maintaining balance in the midst of flux. In terms of the Chinese influence, it is possible that he transposed the principles of the ancient pre-Taoist oracle of change, the *I Ching*, to produce his collages in which rectangles are arranged 'according to the laws of chance' (Figure 15). A central influence on Taoism, the *I Ching* had been concerned with predicting patterns of change at work in nature and, by extension, in the human world. When consulting it, the interlocutor submits him/herself to chance by throwing yarrow sticks (or coins these days) to produce a series of abstract 'hexagrams' which then correspond to one of the book's oracular pronouncements. In dropping his rectangles of paper, Arp was similarly opening himself up to nature's laws rather than man's, although there was clearly no predictive dimension.

In Berlin Raoul Hausmann also appears to have been reading Lao Tzu around 1918, but in addition he was attracted to the thought of the German Darwinian biologist Ernst Haeckel who had discerned a single principle, his 'Law of Substances', as uniting spirit and

matter. All of this supports the historian Richard Sheppard's conviction that the Dadaists' irrationalism and anti-art iconoclasm was fundamentally keyed to a deeply philosophical quest. One pole of Dada, mainly in Zurich, although this extends to non-Communist Berliners such as Hausmann, was concerned with the interaction between models of nature as chaotic and models of it as inherently patterned. The other pole, that represented by Duchamp and Picabia in New York and Paris, or George Grosz and Walter Serner in Berlin, was more fundamentally existential and inclined towards nihilism. This certainly corresponds with the received wisdom whereby Dada in Zurich is essentially more 'constructive' than its New York or Paris counterparts.

Turning to Surrealism, we find little of Arp's or Hausmann's nature mysticism, not least because Expressionism, which had contained the vitalist impulse for their interests, had little impact on the French movement. Instead, Surrealist models of anti-dualist thought often tended to derive from medieval and post-medieval Western hermetic traditions. Alchemy in particular was of major interest to nearly all of the major writers and theorists in the movement. Combined with allusions to astrology and the four elements, it crops up constantly in visual Surrealism. Fundamentally alchemy was concerned with transmutation and thus we find it informing the multivalent imagery of, say, André Masson. In his *Birth of Birds* (Figure 16) the image of a bird soaring up from the woman's vulva has direct associations with images of symbolic birds either flying upwards or downwards in engravings of the alchemical vessel, the place where transformations of matter were effected, while the whole drawing employs metamorphic imagery to thematize birth. Masson, incidentally, is possibly closer to the nature mysticism of Arp than almost any other Surrealist and was deeply affected by Heraclitus. However, in Miró's work (Figure 19) we can also find allusions to a teeming, mystically patterned universe, this time in line with the philosophies of Ramon Lull, the 13th-century Christian mystic whose Catalan roots Miró shared.

It is important to stress that alchemy was redolent for the Surrealists of a particular late medieval worldview and had few of the associations with the occult that it has in the popular imagination. In general the Surrealists had little interest in the supernatural, especially in so far as it was associated with 19th-century crazes such as spiritualism. Breton was at pains to point out that the trances undergone by the Surrealists during the 'mouvement flou' had nothing to do with communication with the dead. Surrealism's finest critic Walter Benjamin stressed that what interested the Surrealists was the 'profane illumination' to be obtained from material existence rather than any recourse to religion or the 'beyond', or drugs for that matter, and we should bear in mind that Surrealist interests often had to be squared with Marxism.

Despite this, we know that Breton had an early fascination with the thought of the French 19th-century writer on magic, Eliphas Lévi, although Lévi himself was a materialist, dedicated to the reconciliation of spirit and matter. This returns us to the Surrealist understanding of alchemy. On the one hand, the group were attracted to the sheer oddity of old hermetic engravings allegorizing the spiritual import of the physical processes of alchemy. Max Ernst's illustrations for the 'collage novels' he produced in the late 1920s and early 1930s owe much to such precedents. On the other hand, the Surrealists anticipated the sophisticated way the psychologist Carl Jung would interpret alchemy in his 1944 book *Psychology and Alchemy*. Here Jung argued that whereas Christianity emphasized redemption from sin, implying a distrust of the flesh, the Hermeticists had used alchemical allegory as a form of commentary on Christianity, emphasizing the reconciliation of matter and spirit through the conjoining of the male and female principles in the symbol of the androgyne. All of this clearly corresponds with the Surrealists' overall attack on Catholicism, and it is not surprising that the androgyne has wide currency in their art and writing. We should, however, recall the essay by Georges Bataille discussed in the last section where the fusion of opposites

produces monstrosity rather than reconciliation. This was the flip side of Surrealist metaphysics.

If alchemy summoned up an alternative philosophical worldview, an important strand of Surrealist art dealt with undermining the categories by which knowledge itself, in the post-Enlightenment world, has been organized. In this respect the Surrealists were particularly interested in the 16th- and 17th-century tradition of the 'Wunderkammer' or 'cabinet of curiosities'. Within their confines, such cabinets had presented alternative modes of ordering and classifying objects, both man-made and natural, to those employed in the museums that would eventually replace them. Principles of analogy or whimsical association took precedence over principles of species and genus. The Surrealists flirted with alternative taxonomic systems in various contexts. Their own personal art collections tended to be organized so that paintings by, say, Dalí or De Chirico were displayed on a par with exotic natural objects or 'primitive' artefacts. By the same token, Dalí produced a 'Surrealist object' in 1936 consisting of a tray of objects, including a shoe, several decorated pastries, and a small ornament of a couple having sex, which was painstakingly assembled according to a personal, fetishistic logic, and Joseph Cornell, the one rather late fully fledged American addition to the Surrealist movement, devoted his entire career to the production of open boxes, usually no more than 18 by 12 inches square, in which objects such as clay pipes, apothecary jars, and star charts evoked a miniaturized world of reverie.

This aspect of Surrealism can be updated a little by looking at a striking image by Jan Švankmajer, the Czech animator and filmmaker mentioned in the last chapter, who practises a sophisticated late form of Surrealism. In the early 1970s Švankmajer produced a large series of etchings, under the collective title *Natural Science*, in which sections of illustrated plates of animals and their skeletons are yoked together to produce disturbing hybrids. There is a deliberate homage here to Max Ernst, who published a portfolio of frottages titled 'Histoire Naturelle', but

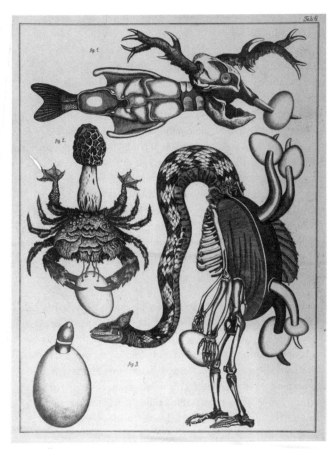

25. Jan Švankmajer, *Natural Science*, etching, 1973

Švankmajer reinvigorates the Ernstian legacy. Švankmajer also produced outrageous mock-scientific notes to accompany his aberrant taxonomies. In the case of 'Fellaceus Oedipus' (Figure 25) we are told of a monstrous Australian animal species in which the female lays eggs from which male progeny emerge by breaking the shells with their penises. The mothers proceed to fellate their newborn male young, swallowing their sperm to fertilize more eggs.

They then castrate their offspring by shutting their jaws, ensuring that all adults are effectively 'females'.

The black humour involved here and the knowing play on psychoanalytic ideas are fully in line with mainstream Surrealism, but Švankmajer's perverse scrambling of natural data is keyed very precisely to his identity as an artist within the Czech Surrealist tradition. Prague had been home to possibly the largest late 16th-century Wunderkammer, that of Rudolf II, and Švankmajer's work looks back ironically to the marvels of this collection. This in turn says something about the way in which an alternative knowledge-system inevitably springs from 'local' rather than 'universal' roots. It also comments obliquely on the presuppositions of a Paris-centred notion of Surrealism, a theme which resonates with the Surrealist discourse around colonialism which, during the 1930s and 1940s, served to temper the movement's Francophile tendencies.

Despite the ingenuities of Surrealist subversions of categorization, it might be asserted that they were still playing to the rules of Western intellectual traditions. In counterpoint to this, there was an atavistic return to the 'primitive', in both Dada and Surrealism, which could be seen as combating Western presuppositions about human nature more directly. This would return us again to the anti-humanist current of Bataille's thought; his interest in opposing the radically unassimilable to the idealist habits of Western thought. But it is a discussion which will have to wait until the next chapter. What is clear from the above is the extent to which the Dadaists and Surrealists employed mystical and hermetic models of thought to contest Western dualism from within. What they sought, as the Surrealists constantly affirmed, was emancipation. But Bataille would no doubt have countered that this emancipation worked in favour of the spirit or mind. What was envisaged for the body?

The bodily and the erotic

St Paul, in his Letter to the Romans 7: 21–4, asserted: 'My inner being delights in the Law of God. But I see a different law at work in my body . . . It makes me a prisoner to the law of sin which is at work in my body'. This kind of religious denigration of the body brought about a violent 'return of the repressed' in Dadaist and Surrealist art. For instance in March 1920, in the early days of Paris Dada, Francis Picabia published a reproduction of an ink splash, with the title 'Holy Virgin', in his journal *391*. Apart from being an example of a chance process, which, like Arp's earlier Zurich collages, was also 'abstract', this Dada ink-pellet had blasphemous implications. According to Catholic doctrine the Holy Virgin did not experience 'venereal pleasure' in conceiving Christ, and effectively remained 'intact'. What Picabia's splash evoked as much as anything was the grossly physical outcome of an all-too-human defloration.

This compelling example of the re-emergence of tabooed aspects of bodily experience speaks to a wider concern in both Dada and Surrealism with the rejection of conventional moral criteria. But did all of this simply amount to an Oedipal assault on the paternal culture or was some new role for the body envisaged?

In Dada, it is surprising to find that the body is rarely seen in sensual terms. Dance admittedly played a fairly prominent role in certain of the Galerie Dada performances of the Zurich group. The Hungarian-born dance pioneer Rudolf von Laban, who, in defiance of classical precepts, based his dances on the organic movements of the body and on principles of tension and relaxation, devised a number of contributions to Dada evenings, with his star dancer Mary Wigman specializing, as one critic noted, in 'elegant deformation'. Dada's founder Hugo Ball, who was an enthusiastic proponent of new forms of dance, wrote about an abstract dance entitled *Song of the Flying Fish and the Sea Horses* performed at the Dada Gallery in 1917 by Sophie Taeuber, the partner of Hans

Arp: 'It was a dance full of flashes and fishbones, of dazzling lights . . . The lines of her body break, every gesture decomposes into a hundred precise, angular, incisive movements.' However, these innovatory dances, which bespeak an attempt to rid the body of constricting habits of expression, and which were at one, in terms of Laban ideology, with experiments in alternative lifestyle involving nudism and vegetarianism, were not, in the strictest sense, motivated by Dada concerns. They sit a little oddly next to the edgier, more anarchic aspects of Dada performance, including the 'negro dances' of the male Dadaists.

Beyond this, the bodies we find in, say, George Grosz's Berlin Dada graphics (Figure 13) are ravaged by urban existence and the effects of war. In a poem of mid-1917, reflecting on a nervous breakdown suffered as an outcome of his war service, Grosz described himself as a 'machine whose pressure gauge has gone to pieces' and most of the Berlin Dadaists registered the effects of traumatizing war-induced disorders such as 'shell shock' on the bodies and facial expressions of the figures they depicted. Hausmann's sound poetry might even be understood as mimicking the stuttered recovery of speech by war neurotics undergoing therapy. By the same token, the mechanized beings of Duchamp or Picabia invoke bodily alienation. A separate case should perhaps be made for Duchamp's *Large Glass*. Given that its mechanomorphic sexual participants are fuelled, according to the notes he made to accompany the work, by forms of energy such as gas and electricity, it could be seen as envisaging a newly 'productive' bodily economy, albeit one provocatively set up in dialogue with the sphere of nature.

Like the Dadaists, the Surrealists produced images of wounded or injured bodies, opposing the French government's attempts to restore national confidence after the war with stubborn reminders of the violence done to the (male) body during the conflict. Figures propped up by crutches became a recurring motif in Dalí's work, particularly his 1933–4 illustrations to Lautréamont's *Chants de Maldoror*, one of Surrealism's 'bibles', in which the book's narrator,

Maldoror, is himself an emasculated, mutilated travesty of masculinity. When it came to representing the female body, however, the Surrealists openly celebrated it, in line with their heterosexual impulses. Although frequently fragmented, the Surrealist body is thus more often pledged to pleasure, or pleasurable pain, than trauma. 'The omnipotence of desire', wrote Breton, 'has remained, since its beginnings, Surrealism's sole act of faith.' In line with the pseudo-scientific tendencies of the movement, a series of twelve 'Researches on Sexuality' were conducted between 1928 and 1932 in which group members were quizzed, in remarkably frank fashion, about their sexual practices and preferences:

> André Breton: Valentin, what do you think of the idea of masturbating and coming in a woman's ear ?
> Albert Valentin: I wouldn't dream of it. . . .
> Pierre Unik: The ear is made for the tongue, not for the cock. . . .
> Georges Sadoul: And in the nose?
> Paul Eluard: I wouldn't like that. I hate noses. A complex. I'm against.

These sessions, only two of which were published in *La Révolution Surréaliste*, brought out the profoundly masculine and homophobic biases of the movement. Breton threatened to leave the room when one session's discussion veered too close to an acceptance of homosexuality. On another occasion, Louis Aragon, who emerges as more open-minded, particularly with regard to homosexuality, ventured that the discussion concerned was 'partially undermined' by the 'predominance of the male point of view'.

A male viewpoint inevitably dominates the enormous amount of erotic art, both visual and verbal, produced by the movement. One of the most uncompromising examples is perhaps Georges Bataille's *The Story of the Eye*, a pornographic novel first published under the pseudonym of Lord Auch, in 1928. Although not strictly a Surrealist production, its delirious and disturbing fantasises of sex and

violence, which at one point involve its male and female protagonists raping and murdering a priest, are closer to Surrealism than his other writings of the period. In 1957 Bataille would see eroticism as 'assenting to life up to the point of death', a philosophical position which, although faintly redolent of late 19th-century fin-de-siècle linkages between sex and death, is more profoundly indebted to the thought of the Marquis de Sade. There is little in the work of female Surrealists comparable with this. Of the small group of women who achieved prominence in the Surrealist orbit in the 1930s, only Meret Oppenheim (Figure 22), Toyen (Marie Cernunová) of the Czechoslovakian group, and the Argentinian/Italian painter Leonor Fini emerge as committed proponents of female erotic experience. Fini, who constantly bridled at the patriarchal attitudes of Breton in particular, overturned male erotic stereotypes in images of languorous androgynous male bodies presided over by female deities. In 1944 she illustrated an edition of Sade's *Juliette*, celebrating, in highly personal terms, the independence of a sexualized 'Sadean woman'.

The Marquis de Sade, who was eulogized by Breton in the Second Surrealist Manifesto as 'Surrealist in Sadism', is a crucial figure for appreciating Surrealist attitudes towards sexuality. The notorious 18th-century French aristocrat and pornographer had initially come to the Surrealists' attention via Guillaume Apollinaire, and was lauded by the group for having placed an ethical value on man's rights to libidinal gratification. Sade had been imprisoned for much of his life for 'perverse' practices, notably sodomy. Although in-depth knowledge of Sade's philosophical position did not emerge until the mid-1930s, as the result of investigations by the Surrealist-affiliated poet and historian Maurice Heine, the Surrealists' reading of him can be grasped by looking at Man Ray's 1933 photograph 'Monument to D. A. F. de Sade'.

Man Ray has imposed an inverted crucifix on this photograph to rhyme with the cleft of the buttocks, but the crucifix clearly also has phallic/penetrative implications relating to the Sadean practice of

26. Man Ray, 'Monument to D. A. F. Sade', photograph, 1933

sodomy. In their 'Researches on Sexuality' the Surrealists pronounced themselves advocates of (heterosexual) sodomy, seeing it as an act which, in gratuitously satisfying desire, symbolically flouts the idea that sex, particularly as understood by the Church, is a procreative 'duty'. At the same time it is significant that France, during this period, was obsessed with its declining birth-rate and that procreation was indeed considered to be a patriotic duty. Clearly, then, Man Ray's image implicitly brings anti-procreative,

anti-religious, and anti-nationalist convictions together. Whatever questions we might raise about the coercive and violatory nature of the activities which Sade promoted, and it is important to stress that the Surrealists generally conceived of sex in reciprocal terms, Sade was basically understood by them to strike a blow for the body's rights vis-à-vis those of Church and State.

More than anybody, the German artist Hans Bellmer exemplifies the Surrealists' interest in unfettered and subversive sexuality. Coming to the attention of the group when, in 1934, a remarkable spread of photographs relating to his first *Doll* mannequin were published in the lavish art magazine *Minotaure*, Bellmer's work was uncompromisingly based around fantasies centring on adolescent or pre-adolescent girls. Heavily influenced by a production he saw in Berlin in 1932 of Jacques Offenbach's opera *Tales of Hoffmann*, in which a female automaton plays a major role, Bellmer was to construct two doll mannequins in 1933 and 1935 respectively. The first, which was four and a half feet tall, is no longer extant, but the numerous photographs of it reveal a cross between a heavily abused child's doll and some form of adult sex toy. Its arms are missing, its plaster torso is half-open, one 'normal' leg is constructed from plaster, the other is simply a piece of dowelling terminating in a wooden club foot. The Surrealists, in the wake of certain paintings by Giorgio de Chirico, had turned the mannequin into something of a cult – a cult, incidentally, which, in so far as it extends to the automaton, has interesting relations with the Dadaists' fascination with mechanomophs – but Bellmer's work enters into much more unsettling psychic territory. His second doll would renounce any singular 'identity' and consist of numerous ball-jointed parts, many of them duplicated several times, which Bellmer assembled together for photographic set-pieces. Profoundly disturbing, one of the photographs reveals an unaccountable creature standing before us, in a woodland setting, its upper body consisting of a further pair of legs. In the background a male figure slips behind a tree, eluding our gaze.

Not surprisingly, Bellmer's works have generated a plethora of critical responses, from those who see the works as irredeemably misogynistic to those who, given the fact that the dolls were produced in Berlin in precisely the period that the Nazis were coming to power, read them as oblique responses to notions of bodily and sexual 'normality' promoted in Nazi ideology.

However, the overriding impression is surely one of a compulsive fetishization of the female body. The multiplication of parts such as breasts or legs, locked together in a monstrous algebra, ultimately stems, as Bellmer was well aware, from the classical Freudian notion of the fetish. In a key essay of 1927, building on earlier writings, Freud argued that the male fetishist's fixation on an object or part of the body in lieu of the whole, derives from a particular 'moment' in the formative passage through the Oedipus Complex. This is the moment when the male child unconsciously disavows the mother's lack of phallus, as evidenced by her apparent 'castration'. The fetish thus stands in for the missing maternal phallus and symbolically allays the reminder of castration evoked by the sight of female genitalia. The more the fetish object is asserted, via multiplication or displacement onto other fetish objects, the more the threat recedes. Interestingly, a number of Bellmer's delicate drawings of the 1940s show young girls lying back, entranced, as erect penises emerge from their vaginas. These drawings deal overtly with the fantasy of the maternal phallus. All of this, of course, suggests that Bellmer's art was, although intensely personal, also deeply knowing.

Much of the erotic art of Surrealism has a fundamentally fetishistic character. A representative example would be the concentration on the female torso, hair and neck in Magritte's *The Rape* (Figure 20). But if violation or dehumanization of the body results from this, as Magritte implies in his title, we are surely left asking some important ethical questions. If this section, and this chapter in general, has shown how Dada and Surrealism developed a new iconography of the body to counter dualist thinking, there can be no

denying that this process was predicated on a male viewpoint. Female commentators have justifiably argued that women's bodies, and, by extension, femininity, are often demeaned via the objectification and fetishization visited on the female body in the service of male psychosexual 'liberation', and Surrealism in particular has comparatively little to offer in the way of a counterbalancing female viewpoint. Dada, simply by virtue of being less heavily concerned with eroticism, seems less directly culpable. Here, though, we are starting to think not so much of sexuality or eroticism in general terms, but of gender positioning. We are starting to think, in other words, of the 'politics' of Dadaist and Surrealist representations.

Chapter 5
Politics

'Everything remains to be done, every means must be worth trying, in order to lay waste the ideas of *family, country, religion*.'

This dramatic declaration from André Breton's *Second Surrealist Manifesto* powerfully evokes the uncompromising nature of Dadaist and Surrealist politics. But rhetoric aside, how realistic were the radical political aspirations of these movements? In what follows I will often look to current perspectives on Dada and Surrealism to make their ideological blindspots apparent. The first two sections deal with questions of gender and race. It is here, perhaps, that we most keenly experience our historical distance from these movements. Yet the Dadaists often explore gender issues in ways that are still relevant to us, while the Surrealists were highly prescient in beginning to question Eurocentric assumptions. Considerations of gender and race will lead on to a discussion, in the last section, of the overall political affiliations of Dada and Surrealism. What were their commitments, in an intensely volatile period of Europe's political history, in terms of actual ideologies and political organizations? Were they truly 'engaged'? Do they end up, in spite of all that they stood for, merely as 'art movements'?

Gender

I have already discussed the ubiquity of a male, fetishistic viewpoint in Surrealist representations of sexuality. But does this amount to saying that the Surrealists had a predominantly negative attitude towards women in general? And how does their attitude compare to their Dada predecessors?

The art historian Whitney Chadwick has certainly argued persuasively that women in the orbit of the Surrealist movement tended to be idealized as muses, and thus stereotyped in the male imagination as archetypes such as the sorceress or child-woman rather than credited with autonomy of their own. Such women, who were often girlfriends or wives of the artists, such as Breton's insane muse Nadja or Dalí's wife Gala, existed, in Chadwick's words, to 'complement and complete the male creative cycle'. Even women who acquired prominence within Surrealism as artists frequently had to do so on the coat tails of a relationship with a male Surrealist; several of the major female entrants into the movement of the mid-1930s to early 1940s, namely Meret Oppenheim, Leonora Carrington, Leonor Fini and Dorothea Tanning, had romantic attachments to Max Ernst. In the case of Jacqueline Lamba, who was Breton's wife in the later 1930s, it was necessary to go through a divorce before she could shake off her status as muse and pursue her own artistic path.

If Surrealism smothered women with idolatry, in line with its cult of desire, Dada often provided more breathing space for female creativity. The relationship between Hans Arp and Sophie Taeuber in Zurich is a case in point. Arp and Taeuber worked collaboratively on some of the earliest Zurich Dada abstractions, produced around 1915–16 in advance of the founding of the Cabaret Voltaire. Certain of these were wool hangings, designed by Arp but worked by Taeuber who at that time taught design at the Zurich Art School. By exhibiting textiles, with their associations with the applied arts or crafts, in a fine art context, Arp and Taeuber could be seen as

strategically introducing a technique connotative of 'feminine' decoration into a formerly 'masculine' domain, and thus not only challenging the traditional predominance of oil painting in a Dada spirit, but also questioning a male-centred conception of creativity. Admittedly Arp often took the credit for these works, but the strategic import of the gestures remains undiminished.

Women flourished in other Dadaist relationships. Raoul Hausmann and Hannah Höch's in Berlin, although stormy owing to double standards on Hausmann's part, which involved him preaching about free love while refusing to abandon his marriage, nevertheless gave Höch considerable creative freedom. Certain of her photomontages debunked marriage (Figure 18) and others explored the position of the 'New Woman' of early 1920s Weimar Germany, registering the way in which images of women participating in sports or popular culture served the commercial interests of advertisers as much as the political requirements of feminism. Beyond this, male Dada tended to be as masculinist as Surrealism.

To return to the male Surrealists, we should be wary, however, of hasty judgements regarding their approach to women. It could be argued that they unthinkingly reproduced the attitudes of their times in relation to women colleagues, whilst often projecting positive attitudes towards femininity in their work. In this respect, it is worth returning to a psychoanalytic theme, that of Hysteria. This condition, which was almost exclusively limited to female patients, had notoriously been investigated in the late 1870s by Freud's teacher, Charcot, who had held public lectures at the Paris Salpêtrière during which patients obligingly fell into the swooning states characteristic of the illness. Although Freud eventually deduced that hysterical symptoms were indicators of sexual repression, the Surrealists chose to downplay the condition's pathological dimension, celebrating it as a 'means of expression' in *La Révolution Surréaliste* in 1928. Not surprisingly, feminist theorists have criticized the Surrealists for overlooking the social marginalization, subordination, and suffering involved in such

supposedly 'poetic' states. However, Elizabeth Roudinesco, a historian of psychoanalysis, has linked the Surrealists' veneration of hysterics to their advocacy of female criminals such as the Papin sisters (Figure 10) or Violette Nozières. The latter had been the focus of considerable interest in France in 1934, having poisoned both of her parents and proved spectacularly deranged in the subsequent trial. In applauding such women, Roudinesco sees the Surrealists endorsing a dangerous, subversive femininity which was the precursor of a specifically modern form of liberated female consciousness.

The idea that the Surrealists' claustrophobic veneration of femininity was actually politically enabling extends to the art historian Rosalind Krauss's argument that even the explicitly fetishistic, objectifying images of women in Surrealist art can be seen in proto-feminist terms. If, according to Krauss, fetishism is understood as a 'perversion' of a 'normal' relation to sexuality, it implicitly valorizes the artificial over the natural and suggests that, far from being a natural given, the category 'woman' is a social construct. On this view, Bataille's transgressive pursuit of hybridity, or Bellmer's obsessive conglomerations of sexual parts, are oddly liberating in their refusal to idealize an essential 'femininity' and their acknowledgement that representation is in any case fundamentally unnatural. However, feminist opponents of Krauss have been quick to argue that being linked to artifice does not necessarily liberate women; after all, fashion advertising is pre-eminently based on artifice. Furthermore Susan Rubin Suleiman suggests that the Kraussian emphasis on fetishism is itself based on patriarchal assumptions in so far as fetishism, in Freudian terms, involves the male unconscious blocking out the possibility of female castration via the substitution of objects connotative of the maternal phallus. The logic of the phallus is thus left in place. It follows from this that Surrealism inevitably upholds a masculinist symbolic system, and that it would be counter-productive, in terms of gender politics, for women to subscribe to male structures of representation.

Female Surrealist artists certainly challenged fixed ideas about their gender. An important figure here is Claude Cahun. Born Lucy Schwob in Nantes, France, she adopted her pseudonym in order to reinforce the sexual ambiguity that is often the subject of the searching self-portrait photographs she produced in the 1920s and 1930s. This ambiguity fooled historians for many years. Cahun does not even appear in the index of Whitney Chadwick's book *Women Artists and the Surrealist Movement* (1985) and had to wait until the late 1980s to be rediscovered. Her photographs present her in a variety of guises – from body-builder to Japanese puppet – such that her femininity becomes something manifestly 'constructed'. In one self-portrait (Figure 27) her severely mannish appearance clearly hints at her lesbianism. Aware that women in visual representations are often the object of the (male) gaze, Cahun meets our look head-on. Meanwhile her mirrored double gazes elsewhere.

Another recently rediscovered woman artist, this time with links to New York Dada, is the Baroness von Freytag-Loringhoven. The Baroness, who had indeed been married to a German Baron but ended up in New York penniless and obliged to pose for artists for a living, was an intriguingly eccentric figure. She often walked through Greenwich Village wearing a coal scuttle on her head or with cancelled postage stamps stuck to her face. But her contributions to the movement were arguably minor, with the notable exception of *God*, a readymade of 1917 consisting of plumbing pipes held upright in a mitre box, and she seems to have been the butt of the humour of Duchamp and Man Ray, 'starring' in a scurrilous, and ultimately abortive, film project conceived by the pair in 1921 which involved her having her pubic hair shaved. It is important, then, to be wary of over-zealous revisionism. There is a danger of skewing a figure's actual relation to historical circumstances. The rediscovery of previously neglected women has been a hugely important enterprise in Dada and Surrealist scholarship, but it has its own problems. It may seem appropriate to write artists such as the Baroness into narratives of Dada and Surrealism rather than ghettoizing them as 'special cases'. That has

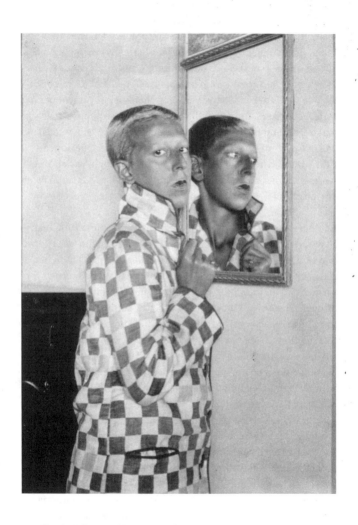

27. Claude Cahun, *Self-Portrait*, photograph, 1928

partly been my strategy in this book. But does that process reinforce their historical submission to male-centred cultural ideologies?

Historians may, in any case, have failed to appreciate the degree of self-reflexivity involved in the work of certain male Dadaists and Surrealists. However much their attitude to women makes them children of their times – women in France did not receive the vote until after the Second World War – these men may still have understood their own masculine identities to be in some way unstable or open to question.

Masculinity is expressed in complex ways in Dada and Surrealist art. Potency, and its procreative outcomes, is a theme which is often touched upon, though surprisingly rarely discussed in the literature. Max Ernst, for instance, produced two semi-abstract Surrealist paintings in 1934 entitled *Blind Swimmer* in which the title itself poetically alludes to the male organ and to the passage of sperm, while simultaneously evoking the sheer ineluctability of libidinal energy. Blindness in Ernst's work is linked to the theme of inward-turned visionary experience, and this suggests a degree of sublimation of the blatantly sexual implications of the theme. We can see a similar process at work in André Masson's *Birth of Birds* (Figure 16) where procreation is made analogous to the generation of images in the (male) artist's unconscious: the vulva gives birth to soaring birds which, on the most elementary metaphorical level, evoke 'flights of imagination'. If we compare this representation of birth to one by a female Surrealist-affiliated artist, the Mexican painter Frida Kahlo, some significant differences emerge (Figure 28). Kahlo's strikingly original image, in which she pictures herself emerging from her shrouded mother's body, was stimulated partly by her mother's death and partly by the death of her own unborn child. In effect she gives birth to herself. Her work implicitly repudiates the lyricism of male evocations of procreation, asserting that birth is physically messy and emotionally traumatic.

However idealistic the male Surrealists were in their attitudes to

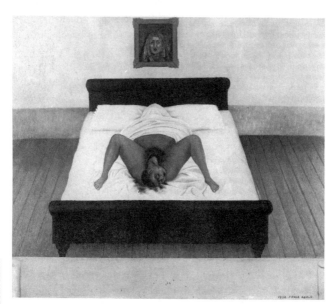

28. **Frida Kahlo, *My Birth*, painting, 1932**

reproduction (and it would be tempting to resurrect the discredited psychoanalytic concept of 'womb envy'), it is clear that they reflected on their own reproductive capacities, and those of women, with some candour. Much as they fetishized women, they were remarkably revealing about specifically masculine ways of conceptualizing sexuality. In that sense, their approach can be aligned with our current interest in 'deconstructing' masculinity. This concern is most urgent, however, within Dada.

More than anybody, Marcel Duchamp in New York had explored the phenomenon of sexual difference in his *Large Glass*. Masculinity, or rather male insufficiency, was one of its central themes. In his notes for the work Duchamp asserted enigmatically that the Bachelors in its lower half, who are trapped in what he describes as their 'malic moulds', 'will never be able to pass beyond the mask'.

In 1921–4 Duchamp himself slipped into the guise of a female alter-ego, Rrose Sélavy, in a series of photographs taken by Man Ray. These images sit interestingly alongside the 'self-portraits' we have looked at by Claude Cahun (Figure 27). In comparison to Cahun's gender-shifts, Duchamp's seem somewhat half-hearted. In one of them Rrose's facial complexion looks suspiciously rough, as though Duchamp is acknowledging the ineffectiveness of the masquerade. To recall Susan Rubin Suleiman's point about the patriarchal basis of Dada/Surrealist iconography, this could be interpreted as indicating that Rrose secretly possesses the phallus: in psychoanalytic terms, she is a 'phallic mother'. This might give a straightforwardly misogynistic inflection to the episode, but it might equally be argued that Rrose represents some ironic response to the emergence of the newly liberated 'femme homme' (mannish woman) in France and America in the early 20th century, which, to a degree, Claude Cahun embodies, although her self-images post-date those of Duchamp. Duchamp seems to have toyed with a male separatist ethos in his life as much as his work, staunchly preserving his bachelor status, as well as allegorizing a male-directed art discourse in works such as *Fountain* (Figure 3). All of this may be seen as a dandyish response to female separatism. Rather than harnessing the feminine to 'transform life' along Surrealist lines, he implies that the male artist should redefine his own gender.

Questions of race: 'Primitivism' to anti-colonialism

If Dada attitudes to gender seem more in tune with our current political attitudes than those of Surrealism, a different case can be made regarding racial issues. It is necessary first, however, to consider the question of 'primitivism'. So-called 'primitive art' held a wide fascination for artists in the early 20th century, ranging from Picasso to the German Expressionists. A particular cult developed around African masks. They suggested ways of radically simplifying the human form (Picasso is famously said to have talked of them as 'raisonnable') but also of returning, atavistically, to primal 'origins'

as part of a modernist critique of the over-sophistication of European culture.

This attitude spilled over into Dada. Looking again at Janco's painting of the Zurich-based Cabaret Voltaire (Figure 2) the artist has recorded the presence of a large mask hanging on the wall behind the stage, while the Dadaists on stage could conceivably be wearing the gaudily painted masks, crudely assembled from cardboard and twine, that Janco himself produced for their performances. We know from Hugo Ball's diaries that 'negro dances' were part of the staple diet of Dada manifestations. The performers seem to have understood them in ritual terms, as bound up with the phenomenon of 'possession': Ball writes: 'not only did each mask seem to demand the appropriate costume; it also called for a quite specific set of gestures, melodramatic and even close to madness'. Few of the Dadaists, however, would have appreciated the exact cultural contexts for the pieces, except perhaps Tristan Tzara, who later wrote articles on African and Oceanic art. In Berlin Hannnah Höch produced a series of photocollages around 1925–30 entitled *From an Ethnographic Museum* in which she provocatively placed photographs of black tribal masks on white European female bodies as a critique of normative Western notions of 'beauty'. These works implicitly valued African aesthetics over European ones, but still assumed, in doing so, that Africa was exotically 'other'.

Turning to Surrealism, 'primitive' artefacts were decisive sources of inspiration for artists such as Max Ernst, André Masson, Alberto Giacometti, and Victor Brauner. This time, the objects were the work of American Indians, Eskimos, and Oceanic peoples. African art was less popular with the Surrealists, partly because of its formalist uses in Cubism, whereas Oceanic artefacts in particular were admired for the disorientating liberties they took with anatomy, as well as their elaborate symbolism. In 1929 the Surrealists published a redrawn map of the world in the Belgian Surrealist magazine *Variétés*. On the map France and the USA were completely absent and Polynesia, Mexico and Alaska assumed

gigantic importance. In their works the artists displayed an almost scholarly eclecticism. Giacometti drew on the formal characteristics of Mallanggan figurines from New Ireland as sources for the aggressively disjointed insectoid forms, trapped in an enclosing scaffolding, in his wooden sculpture *The Cage* of 1931. Max Ernst's plunderings were positively voracious, ranging from allusions to Easter Island bird-figures in his paintings of the late 1920s to the use of American Indian Kachina dolls as reference points for his totemic sculptures of the early 1940s.

The scope of the Surrealists' borrowings developed in tandem with the remarkable expansion of ethnographic literature in France as the 1920s progressed. Most of the artists were well versed in the likes of Lucien Lévy-Bruhl and Marcel Mauss, as well as the English anthropologist Sir James Frazer. In France the concern with 'ethnography', comparable to social anthropology in Britain, extended as much to 'belles lettres' as it did to academic specialization, and French cultural life in the 1920s and 1930s saw a massive transformation in attitudes towards 'the primitive' symbolized by the supplanting of the old Trocadéro museum in Paris, with its jumbled collection of tribal exotica, in favour of the Musée de l'Homme (founded in 1937) with its concern for ethnic specificity and the non-hierarchical display of divergent cultural objects.

This important shift was a driving force behind *Documents*, the organ of the dissident Surrealist group around Bataille. Indeed, among its founders and editorial board were Paul Rivière, who set up the Musée de l'Homme, Paul Rivet, co-founder of the Paris Institut d'Ethnologie, and Michel Leiris, former Bretonian Surrealist and trained ethnographer. Its pages are characterized by the cavalier switching between culturally 'high' and 'low' objects and practices, in the context of a relativizing cultural continuum, that the American cultural historian James Clifford has dubbed 'ethnographic Surrealism'. As one of the series of unconventional 'dictionary definitions' published in the journal, 'man', for instance, is summed up as follows by an English chemist:

The bodily fat of a normally constituted man would suffice to manufacture seven cakes of toilet soap. Enough iron is found in the organism to make a medium-sized nail ... The phosphorus would provide 2,200 matches.

Such startling juxtapositions of information have their own exoticism, of course, but in this instance they serve to displace the authority of the Eurocentric notion of 'man', predicated on white skin colour and Cartesian rationality, that had previously been upheld over and against the notion of 'the primitive'.

We have here an opening onto a profoundly anti-colonialist spirit in Surrealist-related discourse, but we have to turn back to 'official' Surrealism, and to André Breton's responses to the rise of the 'négritude' movement in the French West Indies, to appreciate the extent to which Surrealism became actively politicized in relation to ethnicity. The Surrealists had shown opposition to French colonialism as early as 1925 when, as one of their first explicitly political acts, they had publicly supported the Riff tribesmen in their struggle against the French authorities in Morocco. In 1931 they protested against the large pro-colonial exhibition mounted in Paris to celebrate France's territorial might. As well as distributing a leaflet warning people against visiting the event, they mounted an alternative exhibition titled 'The Truth about the Colonies'. One of the vitrines in the show pointedly commented on Western conceptions of tribal objects as 'fetishes', displaying a Catholic statuette of the Virgin and Child next to a collecting box in the form of a black child, with the label 'European fetishes', a succinct allusion to the West's religious and economic fetishism. The late 1930s, however, saw anti-colonial sentiment stepped up via newly established links between the Surrealist movement and writers who were themselves from colonial backgrounds. The prime mover here was the poet Aimé Césaire.

Originally from Martinique, Césaire had studied in Paris in the later 1930s but returned to his home country in 1939. From 1941

onwards, he, along with his wife Suzanne and the philosopher Réne Ménil, published a journal titled *Tropiques* which combined opposition to the Vichy government in Paris and admiration of the libertarian principles of Surrealism with the beginnings of an ideology of 'négritude': an assertion of black identity in the face of the 'assimilationist' ideology underpinning French policy towards its colonies. In 1941 André Breton, at that point in the process of fleeing the German Occupation of France and en route for the USA, visited Martinique, and discovered both Césaire and *Tropiques*. He subsequently asserted that *Return to my Native Land*, a long poem that Césaire had produced in 1938–9, was 'nothing less than the greatest lyrical monument of our times'. This was by no means the end of Breton's relationship with the colonies. In 1945, this time just prior to his return to France from America after the Second World War, he visited Haiti to lecture on Surrealism. Haiti had seen a slave rebellion as early as 1804, but had, since 1915, been under US domination. Breton's presence seems to have worked as a catalyst for dissent among young intellectuals and a revolution broke out, although the Surrealist leader's only overtly political gesture appears to have been refusing to meet the American-backed president of the country. For once, then, Surrealist rhetoric contributed to an actual revolution.

To return to Césaire's poetry, or more particularly *Return to my Native Land*, it is worth underlining the extent to which, far from Paris, Surrealist techniques of incongruous juxtaposition were harnessed to convey a people's resentment at their past suppression and yearning for a new language:

> but can you kill Remorse with its beautiful face like that of an English lady stupefied to find a Hottentot's skull in her soup tureen? … I want to rediscover the scent of great speeches and of great burning. I want to say storm. I want to say river. I want to say tornado. I want to say leaf …

This level of passion is matched in the visual arts, by the work of

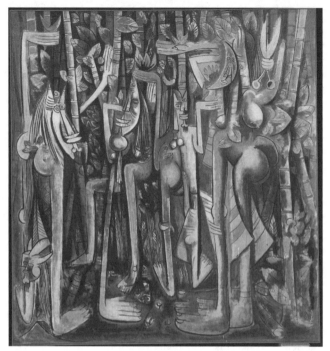

29. Wifredo Lam, *The Jungle*, oil painting, 1943, Museum of Modern Art, New York

another Surrealist-influenced figure who returned to his colonial birthplace after a lengthy immersion in European culture: Wifredo Lam. Originally from Cuba, Lam had trained in Madrid, and been heavily influenced as a painter by meeting first Picasso and then the Surrealists in 1938. His return to Cuba, via Martinique in the company of Breton, led to the production of a major painting, *The Jungle*.

Consisting of a frieze of naked figures hemmed in by a claustrophobic vegetation, the picture employs a generic 'primitivizing' vocabulary derived from Surrealism to cross-relate the innocently exotic forests of the French 'naïve' painter Henri

Rousseau and the formally disjunctive vision of women in a brothel represented by Picasso's seminal pre-Cubist masterpiece, *Les Demoiselles d'Avignon* of 1907. Making us aware of what colonialism has done to the jungle, Lam wrote:

> Rousseau . . . does not condemn what happens in the jungle. I do. Look at my monsters and the gestures they make. The one on the right proffering its rump, obscene as a whore. Look, too, at the scissors in the upper right hand corner . . .

The fact that Surrealism was called upon to articulate the early stirrings of négritude might seem to suggest that it was politicized in relation to ethnic identity. However, the impetus for such gestures had come from outside rather than inside the mainstream Paris-based movement. As late as 1938, the 'official' Surrealists, and Breton in particular, were still capable of exoticizing other cultures. Mexico, for instance, was perceived as the revolutionary country par excellence, having undergone a people's revolution in 1910–17. When Breton visited it in 1938, keen to endorse an international expansion of Surrealism, in line with the development of outposts in Czechoslovakia, Britain, and elsewhere, it was not so much the work of the Socialist Realist Diego Rivera he admired, but that of Rivera's wife Frida Kahlo. Her work, he asserted, was Surrealist, although she had no knowledge of the movement. Kahlo, by contrast, saw her paintings, which were primarily autobiographical, as essentially realist in spirit. Their reference points were highly specific to Mexico. In *My Birth* (Figure 28) the excruciating personal references described earlier were reinforced by the fact that the image was painted as a Catholic ex-voto on tin, as well as being a form of invocation to the Aztec goddess Tlazoltéol, sacred to women who die in childbirth. Breton, for whom identity was essentially something to be questioned rather than striven for, must have seemed insensitive to her quest for Mexican roots, and she appears to have been bored by his theorizing. Fundamentally, he exoticized her, describing her once as 'a ribbon around a bomb', in accordance with customary male Surrealist attitudes.

Certain critics of Surrealism, such as the Cuban writer Alejo Carpentier, have seen its rhetoric as 'universalizing' and its desire to reconcile contradictions, as in Breton's Hegelianism, as tantamount to the *denial* of 'difference', especially in cultural terms, although we have seen that Surrealism was also predicated on a dominant male subjectivity. For Carpentier, European Surrealism simply hankered after the conditions of other cultures, while locations such as Latin America and the Caribbean, where the remnants of magical belief still survived, were its true homes.

With this viewpoint in mind we might even question the latitude of the internationalist ethos espoused by both Dada and Surrealism. Dada, despite the diversity of its locations, was highly Westernized, although recent research on the Eastern European connections of the movement – involving the recognition that Janco and Tzara in Zurich both had ongoing connections with the avant-garde in their native Romania – and the fact that a Japanese movement flourished between 1920 and 1925, suggests that we may soon be seeing Dada as having a broader global scope. In the 1930s Surrealism could be seen sprouting up in locations such as Yugoslavia, Denmark, the Canary Islands, and Japan once again, with an international exhibition being held in Tokyo and Kyoto in 1937, but its overall viewpoint was essentially eurocentric. In 1955, Breton looked back on the Surrealists' veneration for non-Western cultures, and conceded sadly that 'The inspiration we were able to draw from their art remained ultimately ineffective because of a lack of basic organic contact, leaving an impression of rootlessness.' The least we can do is feel the pathos, and admire his honesty.

Political alignments

Dada and Surrealist engagement with the politics of gender and race sprang naturally from their concern for individual liberty, but what about the connections these movements had with the world of 'hard' politics? If we think of Dada as emerging concurrently not just with the First World War but also the Russian Revolution, and

Surrealism as developing simultaneously with the rise of Stalin and Hitler, we might wonder how their focus on individualism and irrationalism could possibly measure up to such momentous political events and options. However, true to the avant-garde impulse to forge links between aesthetic and social experience, both movements established political alignments.

In the case of Dada, it is almost entirely to the Berlin grouping that we must look. The Dadaists in New York and Paris were largely disillusioned with party politics, and generally leaned towards anarchist or anarcho-syndicalist ideas in line with their strongly individualist positions. The Zurich group also favoured anarchy. Ball in particular had a deep intellectual involvement with the writings of its Russian ideologue Mikhail Bakunin, although he would eventually reject the anarchist presupposition that man is fundamentally good, and make a dramatic reversion to Catholicism. As Zurich Dada came to an end and Walter Serner and Tristan Tzara became increasingly negative, certain members of the group, temporarily buoyed up by the possibility of a revolution in Germany, became involved with utopian projects such as the 'New Life' exhibiting group, which looked to the Middle Ages for its ideal of breaking down arts and crafts distinctions, as Arp and Taeuber had already been doing. However, when news arrived from Berlin of the murders of Rosa Luxembourg and Karl Liebknecht, the Zurich group became terminally disillusioned, settling for abstraction rather than politics. Schwitters in Hanover made this an article of faith. In Berlin, however, political realities had to be faced up to.

As already stated, the Berlin group broke down into an anarchist and a Communist faction. The anarchist contingent, notably Raoul Hausmann and Johannes Baader, were, like the Zurich group, attracted to the ideal of small-scale communities, and suspicious of organized political formations; hence Hausmann would write: 'Communism is the Sermon on the Mount organized practically, it is a religion of economic justice, a beautiful insanity'. It is to Herzfelde–Heartfield–Grosz, as card-carrying members of the

German Communist Party (KPD) that we should look to see whether Dada could translate into political ideology.

Looking at *Everyman his own Football* (Figure 12), the journal which this faction published shortly after the murders of Luxembourg and Liebknecht, and which also shows them, fairly uniquely, working in tandem with the anarchist wing of the group, there can be little doubt about their political sympathies. We find within the publication assertions that 'The Revolution is in danger' and a cartoon by George Grosz shows members of the new majority Socialist government in Berlin, depicted as puppets of the Catholic Church, stirring up mass fears of Bolshevism. Walter Mehring recalled how the Dadaists themselves touted this journal through the working-class districts of the city, accompanied by a small band. It sold a remarkable 7,600 copies on 15 February 1919 before being officially banned.

Herzfelde's left-wing publishing house, Malik-Verlag, next published several issues of a journal entitled *Die Pleite* (Bankrupt!). The markedly pro-Soviet stance of this magazine landed Herzelde in prison for two weeks. After he came out, issue 3 of the journal bore a cover by Grosz referring pointedly to the massacre of the Spartacists, in which the Defence Minister Gustav Noske, a sword in one hand and a glass of champagne in the other, stands in a street littered with corpses. The sarcastic caption beneath reads: 'Cheers Noske – the Proletariat is disarmed!'

A powerful satirical edge is displayed here, but the Herzfelde–Heartfield–Grosz faction did little to serve the Communist cause in Germany after the overthrow of the Spartacists. Herzfelde was frequently critical of the KPD, ridiculing its anti-intellectualism and lack of leadership. The Dadaists looked elsewhere for their ideals; mainly to Soviet Communism, but also to the machine-age mystique of the USA, the subject of some idealization in certain Heartfield and Grosz photomontages. Heartfield would later contribute brilliant attacks on Hitler's rise in Communist

publications, but at its height Berlin Dada did little to endorse Communism in Germany. The KPD in turn was lukewarm towards Dada. The main criticism levelled at the movement was that it was producing advanced, revolutionary art before a revolution had occurred. How could the proletariat possibly understand its language?

If this criticism appears to hobble Dada's politics, it proved to be the recurrent bugbear of the Surrealists' concerted attempt to align themselves with the French Communist Party (PFC) in the period 1926–35. Like the Dadaists, the Surrealists were fundamentally individualists, but Breton deliberately modelled Surrealism as a movement, with its constant appeals to group solidarity and its expulsions, on the principle of a political collective. Essentially, he sought to reconcile Freud and Marx. Man's mental freedom, Breton believed, should be sought concurrently with a revolution on the social plane. (Little on the whole was said about women's rights.) In terms of actual politics, however, this was like attempting to square the circle.

The Surrealists' first serious setback came in 1927, when, as they attempted to establish links with the PFC, one of their own members, Pierre Naville, questioned their assumption that a mental revolution could precede a material one. Although the Surrealists officially joined the Party that year, they were constantly viewed with suspicion because of their bourgeois 'art for art's sake' attitude and a lack of demonstrable proletarian links. In the *Second Surrealist Manifesto*, taking up the position of Trotsky, whose expulsion from Russia the Surrealists deplored, Breton asserted that, whilst Surrealist art could hardly be considered 'proletarian' it was nevertheless revolutionary, pointing the way to what proletarian art might be in a post-revolutionary situation. The Party remained unconvinced, and Breton, having been hauled before various committees, was duly assigned to a gas worker's cell in Paris and asked to report on the economic conditions of heavy industry in Italy; a task, of course, to which he felt unequal.

In 1932 matters came to a head with the so-called 'Aragon Affair'. Louis Aragon had begun to diverge from official Surrealist policy when, in 1930, he had represented the group at a congress of revolutionary writers in Kharkov in Russia and had assented to criticisms of their Trotskyism while misrepresenting their views in other respects. In 1931 his increasing commitment to the Party call for 'proletarian literature' led to him publishing a poem titled 'Red Front' in the communist magazine *Literature of the World Revolution*. The poem exhorted the working classes to revolutionary struggle with phrases like 'Kill the Cops' and 'Fire on the trained bears of social democracy'. It was essentially propagandist, and far removed from Surrealist taste, but when the French authorities, keen to crack down on Communism, threatened an unprecedented indictment of the poet on grounds such as incitement to murder, the Surrealists staunchly defended him. Later, however, when called on by the Surrealists to endorse a text by Breton defending Salvador Dalí against an attack in the Communist press, Aragon was unwilling to defy the Party openly. As a result he split decisively from Surrealism. He was subsequently to commit himself to the aesthetic position favoured by international Communism, as it moved in late 1934 from 'proletarian literature' to 'Socialist Realism'.

The Socialist Realist credo, whereby art should be socialist in content and realist in form, effectively ended any possibility of Surrealist compliance with Communist policy. In 1935 the group were officially excommunicated from the Party. Other outposts of Surrealism fared better than this, incidentally. In Czechoslovakia, the group's theoretician, Karel Teige, edited the Communist Party journal, ensuring that articles on Surrealism appeared in it regularly. This group was not to break with the Party until 1938.

Back in France, the years of the 'Front Populaire', when Communists and the parties of the Left joined forces to oppose the rise of Fascism, saw the Surrealists continuing to hold an anomalous position, being virulently anti-Fascist but suspicious of

nationalist inclinations on the Left. For a short period Breton and his old antagonist Georges Bataille joined forces under the banner of 'Contre-Attaque', with Bataille in particular speculating wildly on how the forces unleashed in the masses by Fascism might be harnessed to bring down capitalism. In 1936 Benjamin Péret, alone of all the Surrealists, went to join the anarchists in the Spanish Civil War. Finally the Surrealists gave up on the Communist Party, with news of the 'Moscow Trials' confirming their long-standing doubts about Stalin.

In a sense the finale to the story of Surrealism's frustrated attempts at political alignment is the manifesto, entitled 'Towards a Free Revolutionary Art', which Breton co-authored with Leon Trotsky (although Trotsky asked Diego Rivera to sign the declaration on his behalf) when, in 1938, the Surrealist leader visited his political hero in Mexico. With the world on the brink of capitalist collapse, tyrannized by Stalinism and Fascism, Breton and Trotsky definitively reiterated a doctrine of artistic inviolability in the service of Marxism: 'The independence of art – for the revolution. The revolution – for the independence of art.' The sorry aftermath to this was that, when Breton returned to France, he found that one of his oldest allies Paul Eluard had been writing for a Stalinist journal, precipitating another definitive split at the heart of the Surrealist movement. A defeated Breton was to go into exile in the USA for the duration of the Second World War. On his return in 1946 he would find that Eluard, along with Aragon and the former Dadaist Tristan Tzara, had become the literary heroes of the Resistance, while Jean-Paul Sartre and Existentialism were poised to dominate French cultural life. Surrealism, and Breton's principled intransigence in relation to commitment, was a thing of the past. Indeed the general mood was one of bitterness. Tristan Tzara asked: 'What is Surrealism today and how does it justify itself historically when we know that it was absent from this war, absent from our hearts and from our activities during the Occupation?'

This chapter on Dada and Surrealist politics might appear to be

ending on a down beat. The most obvious conclusion to this final section would seem to be that, however successful it was culturally, Surrealism failed in political terms, although its engagement with colonialism is a significant legacy. Dada, by dint of largely eschewing conventional politics, could hardly be said to have failed; its own negativism in any case allowed for that. However, Surrealism's idiosyncratic melding of Marx and Freud was only found wanting in relation to 1930s Communist ideology, and not everybody would see that as a fair test. Surrealism's idealist and fundamentally impractical brand of politics remained out of favour for many years after the Second World War, but it had a significant renaissance in aspects of New Left thought in the 1960s. If we look to Surrealism's reception by the French Situationists, for instance, who were to play a small role in the 1968 uprisings in Paris, we can see a new valuation being placed on its political instincts. The Situationists inherited from Surrealism, via the Marxist theorist Henri Lefebvre who had himself been closely associated at one stage with the movement, the overall conviction that everyday life, including dreams, sexual relations, the negotiation of urban space, and so on, is the terrain on which revolution should occur.

In 1970 Raoul Vaneigem, a Situationist theorist who has received less attention in recent years than Guy Debord, and who had much to say about the movement's debt to Surrealism, wrote a short book (originally under the pseudonym J.-F. Dupuis) entitled *A Cavalier History of Surrealism*. Here he lamented Surrealism's implicit assumption that it could 'reach the masses' via the Communist Party, not least since this made the movement subservient to a political bureaucracy that would turn Surrealism's dream of cultural revolution 'on and off like a tap'. Interestingly he points to Breton's post-war turn to the writings of Charles Fourier, a French utopian socialist of the early 19th century, as the means by which Surrealism might have been truer to its political inclinations. Fourier was wildly eccentric in certain respects: Breton noted fondly in his *Anthology of Black Humour* how Fourier 'held that the cherry was the product of the earth's copulation with itself and the

grape the product of the earth's copulation with the sun'. But Fourier was convinced that civilization is built on the repression of 'the passions' and based his monolithic social scheme of 'Phalansteries' (communes) on the principle of 'passionate attraction'. It is hardly surprising that Breton, who particularly balked at the Communist Party's dour advocacy of 'labour', was drawn to Fourier's idea that work should be an outcome of 'attraction', with people matched to tasks they naturally relish: the Phalanstery latrines for instance would be cleaned out by hordes of children who enjoy filth. Breton's distinctive personal melding of sexual libertarianism and systematicity was similarly catered for by the elaborately orchestrated orgies envisaged by Fourier for the Phalansteries.

That such dreams should end up as Surrealism's final ideological refuge seems thoroughly appropriate. Fourier's Byzantine projections are almost a parody of the political bureaucracies the Surrealists had had to deal with, but they were at least predicated on the sovereignty of desire; the true starting point for Surrealist politics. As it was, in adjusting to Communist imperatives, the social aspirations first of Dada, and then of Surrealism, were dragged down by compromise.

Chapter 6
Looking back on Dada and Surrealism

The afterlife of Dada and Surrealism is a subject in its own right, and can only be touched on schematically here. Art, literature, and ideas in general, as well as advertising, film, and TV, were affected by the movements to such a degree that one would virtually end up writing a history of post-1945 culture.

In terms of art, Dada could be said to have had the most wide-ranging post-war impact, a fact which is paradoxical given Dada's anti-art inclinations. For numerous European and American artists of the 1950s and 1960s, Dada performances and the Duchampian readymade represented a radical challenge as to what visual art might be. Ironically, they usually ended up extending the frontiers of art as a result. One important American tendency of the 1950s, involving the artists Jasper Johns and Robert Rauschenberg and the experimental musician John Cage, was fleetingly termed 'Neo-Dada'. Arguably, the works produced had little of Dada's anti-bourgeois acidity. Rauschenberg's assemblage *Bed* of 1955, consisting of a bed raised upright with its pillow and coverlet smeared and dripped with paint, has a confrontational edge due to the way the artist denies the object's normal function, but the productions of Neo-Dada quickly became icons of a new artistic latitude. This process is emblematized by Johns's *Painted Bronze* of 1960, consisting of two casts taken from ale cans mounted on a plinth. Essentially this is a reversal of the idea of

the readymade back into the terms of art. Its implications were not lost on the ageing Duchamp who commented frustrated in the 1960s that he had thrown his readymades into the public's face in a spirit of defiance, only to find them admired for their aesthetic beauty.

If the works of Johns and Rauschenberg can partly be seen as elaborate extrapolations from the idea of the readymade, other variations on Duchamp's gesture were rife in the 1950s and 1960s. These ranged from examples of 'Nouveau Réalisme' in France, with its key practitioners being Yves Klein, Daniel Spoerri, and Arman, to American variants of Pop Art; notably the work of Andy Warhol in which the logos of products such as Coca Cola were utilized with little modification, thus constituting 'readymade' subject matter. By the later 1960s and 1970s the terms of Duchamp's reception had shifted in favour of his conceptual approach to art, whereby, to recall the mock-defence of *Fountain* in *The Blind Man*, 'Whether Mr Mutt with his own hands made the fountain or not has no importance. HE CHOSE IT.' The physical production of art objects was now widely under question, and texts or photographs documented a wide range of conceptual propositions by artists such as Douglas Huebler and Robert Barry. It is important, though, to realize that, in these and many other cases, the Duchampian inheritance rarely went far beyond the issue of 'nomination': the designation of something as art if the artist so decrees. Conceptual Art would develop a variety of thematic and philosophical concerns that ranged far beyond Duchamp. At the same time, Dada in general became a significant precedent for tendencies such as 'Fluxus' (at its height 1962–5) and various aspects of Performance Art. It could even be asserted that the entire structure of 1960s avant-gardism, with its internationalist ethos and its reliance on the dissemination of cheaply produced ephemeral publications, was beholden to Dada's example.

Dada's consequences for the aesthetics of the immediate post-war period were far more decisive than Surrealism's. Admittedly, the

proto-abstract or 'automatist' side of Surrealist art – as in the art of Masson or Miró – was profoundly important for certain Abstract Expressionists in America in the mid to late 1940s, notably Arshile Gorky and Jackson Pollock. However, after this important phase, it is surprisingly difficult to perceive debts to Surrealism in the mainstream art of the 1950s, 1960s, and 1970s. There are significant exceptions within Pop Art, such as James Rosenquist's disorientating juxtapositions of fragmentary imagery or Claes Oldenburg's 'Soft Sculptures' in which familiar forms such as light switches or drum kits undergo sexually inflected metamorphoses from hard to soft. But often the movement's legacy persisted in the work of offbeat fantasists rather than central innovators. At the same time certain outstanding individuals, such as the French-born sculptor Louise Bourgeois, chose to build up discrete bodies of work exploring themes such as sexuality rather than the aesthetic problems synonymous with late Modernism. As the formal underpinnings of Modernist art were eroded during the 1980s and 1990s, Surrealism came into its own as a forerunner of post-modernist sensibility. In 1986 the art historian Hal Foster ventured that 'much contemporary criticism and art, much theory and practice of our postmodern present is partly, genealogically, a theory and practice of "Surrealism"', a comment related to his sense of a return to earlier moments of avant-gardism in late 20th-century art on the model of Freud's 'return of the repressed'.

Foster's observation seems borne out by the rise of American artists such as Robert Gober or, more recently, Matthew Barney, who clearly look back to the baroque extravagance of Surrealist iconography, using its abject or fetishistic bodily imagery to express contemporary anxieties about issues such as AIDS, in Gober's case, or to resurrect myth, in Barney's. Gober's *Untitled* of 1991 consists of a wax cast of the lower half of a male body, wearing underpants, socks, and plimsolls. When shown in galleries it is placed facing downwards on the floor with the stomach flush against the wall so that the figure appears to be disappearing through the wall. More

disturbingly, a series of drainage holes are inserted into the buttocks and legs of the figure. Gober thus uses Surrealist devices to make a complex metaphorical statement relating to male sexuality, disease, and mortality which, at the time the piece was made, resonated powerfully with widespread concern about the AIDS epidemic. At the same time, the Surrealist tradition provided another American artist, Cindy Sherman, with a more direct means of attacking the US establishment's moral retrenchment in the face of work such as Gober's. Drawing on the disturbing 'poupées' of Hans Bellmer, she produced a sequence of photographs in 1992 in which highly detailed medical mannequins were arranged with their genitalia prominently displayed. Given that the American government was at that time attempting to curb the use of explicit sexual imagery, Sherman was making a provocative gesture.

In Britain Surrealist-related issues have become ubiquitous in contemporary art, although their guiding rationale is less clear. The Surrealist fascination with classificatory systems can be found for instance in the work of Susan Hiller, who, as early as the mid-1970s, produced a work entitled *Dedicated to the Unknown Artists*, in which she collected together over 200 seaside postcards, with the inscription 'Rough Sea', depicting waves lashing the British coast. The work amounted to kind of pseudo-anthropological survey of the popular representations of an island-bound race. Cornelia Parker, a nominee for the prestigious Turner Prize in 1997, inclines more to the Surrealist's fascination with the tradition of the 'Wunderkammer' or curiosity cabinet. Hence her photographic work, *Grooves in a Record that Belonged to Hitler* of 1996 invites the spectator to peer at a close-up photograph of the surface of a long-playing record as though some residue of its one-time owner's dark motivations might be discerned in its grooves. Other artists keep alive the Surrealists' interest in incongruous juxtaposition. The Scottish artist Douglas Gordon's *Between Darkness and Light (After William Blake)* of 1997 consists of two films, *The Song of Bernadette* and *The Exorcist*, projected simultaneously on either

side of a transparent screen, so that the films – which deal with good and evil respectively – enter into dialogue with each other. Such works might be said to be allied with the 'softer' poetic side of Surrealism. However, certain artists synonymous internationally with the so-called 'yBa' (young British artists) phenomenon have produced work which is comparable in its gritty intensity to that of Americans such as Gober. Sarah Lucas, whose work was discussed at the start of this book, is a case in point.

If we look at Lucas's photographic work *Get Off Your Horse and Drink Your Milk* of 1994 (Figure 1) in relation to one of its generic reference points, René Magritte's Surrealist icon *The Rape* of 1934 (Figure 20), we can see that she presents an aggressively feminine take on Magritte's self-reflexively misogynistic image. Lucas prods at a Surrealism gone flabby through its assimilation into the market place. She replaces the markers of virile masculinity with symbols of infantilization (milk bottles, digestive biscuits) and therefore effects a meeting between the 'high' cultural sphere to which Surrealism belonged and the vernacular sphere of street culture, where issues of male and female identity are continually contested.

For Sarah Lucas Surrealist devices are simply part of the currency of mass culture. Although she clearly shares the Surrealists' interest in sexuality, Surrealism is referenced as much in terms of the intensification of commodity culture during the last century, largely through advertising, as anything else. In fact this essentially ironic or revisionary attitude lies behind many of the works I have been discussing. Numerous artists have taken Surrealism as a jumping-off point for their explorations of identity politics but few would wholeheartedly endorse Surrealism. For many it has become too easily identified with images on posters by the likes of Dalí and Magritte. Its populist currency has all but obliterated its underlying value.

Is it possible to find a truly sympathetic continuation of the Surrealist project? The answer lies not so much with mainstream

(post)modern art as with counter-cultural formations or artistic-cum-political manifestations which have something of the self-consciously 'avant-garde' impetus that was identified at the start of this book as characterizing Dada and Surrealism. In this sense, Surrealism's immediate historical progeny would be a group of politicized art formations that emerged in the period before 1968; namely COBRA, an alliance of Belgian, Dutch, and Danish artists, architects, and writers, which lasted from 1948 to 1951; Lettrism, a French movement led by Isidore Isou, and later, as the Lettrist International by Guy Debord, which existed from 1946 to 1957; and Situationism, a mainly French phenomenon spanning the years 1957–72. As noted earlier, Situationism, which by the mid-1960s had actually shed its artistic interests, could be understood as the inheritor of Surrealism's politics of everyday life. Opposed to the modernist rationalization of the city, the Situationists indulged in a kind of wandering, theorized by them in terms of 'dérive' or 'drift', and called in their writings for a 'unitary urbanism' whereby the spaces of the modern metropolis would be reorganized to fulfil the requirements of fantasy or play. There was a direct debt to Surrealism here. In an essay of 1950 entitled 'Pont-Neuf' André Breton had written of the ambiences attaching to streets in cities, such that in familiar streets one could demarcate 'zones of wellbeing and malaise'. We find an echo of this in an important 'report' of 1957 by the Situationist leader Guy Debord, where, envisaging how the 'emotional effects' of an experimental city might be orchestrated, he writes:

> One of our comrades has advanced a theory of states-of-mind quarters according to which each quarter of a city would be designated to provoke a specific basic sentiment to which the subject would knowingly expose himself.

By the middle 1960s the utopian tenor of Situationist thought was shared by various counter-cultural formations. In many ways this could be seen as the last great moment of the Surrealist impulse. The pages of the 1960s British underground magazine *Oz*, with

their delirious mergers of New Left and anarchist politics, psychedelia and sexual provocation, might thus stand as the last, debased, glimmerings of Surrealist ideology. With both Situationism and the counter-cultures of the 1960s it is appropriate to invoke the notion of avant-gardism that was used to define the historical nature of Dada and Surrealism earlier in this book. To a certain extent, the political interests of counter-cultural groups overlapped in this period with art movements such as Fluxus. With this in mind, cultural historians have made tentative use of a notion of the 'neo-avant-garde' to characterize this momentary return to attempts to merge art and life.

It follows from this that if we were looking for a meaningful contemporary legacy for Surrealism, and for Dada as well, we would need to find current equivalents for the artistic-cum-political approach of the historical avant garde or neo-avant-garde. Numerous commentators on post-1970s culture have noted, however, that an avant-garde stance no longer seems viable, not least because it is difficult to imagine any one group having the kind of position on the periphery of social processes that Dada and Surrealism once possessed. Artistic radicalism has been assimilated into the structures of late capitalist culture. Few ambitious artists today would be satisfied with waiting for major exhibitions until the end of their lives, as was the case with, say, Duchamp or Heartfield. Counter-cultural groups of various kinds have sprung up in the wake of the late 1960s, but they have been attached to particular causes such as ecology or women's rights, and have thus avoided the totalizing ethos of Surrealist ideology. The sheer heterogeneity of our current globalized culture means that the idea of speaking 'for humanity' – which is what the Surrealists frequently assumed they were doing – in any event seems absurd.

If the avant-garde is a thing of the past it may also be because credible cultural figureheads of the calibre of a Tristan Tzara or André Breton have simply not emerged. There is no shortage of major French intellectuals who have acknowledged the decisive

formative importance for them of Surrealism. The list would include Roland Barthes, Michel Foucault, Jacques Lacan, Julia Kristeva, and Jacques Derrida. Such figures, however, have felt more comfortable with academic cult status than active cultural leadership. The very idea of such leadership seems hubristic and out of kilter with our age.

Aside from this speculation about Dada and Surrealism's 'survival', it is finally worth asking more bluntly whether the movements actually deserve to survive. Is Sarah Lucas's acceptance that Surrealism is now simply part of commodity culture a recognition that, ultimately, the movement was a historical dead-end?

To focus this issue it is worth returning to the critique of Surrealism by the Situationist, Raoul Vaneigem, as discussed at the end of the last chapter. Vaneigem had a number of valuable things to say in his *Cavalier History*. He argued, for instance, that Bretonian Surrealism often fell short of liberating man on the moral plane. The free play of desire and so on could be seen merely as 'stimulants to the regeneration of the old order'. By contrast Vaneigem advocates the thinking of more extreme Surrealists such as the Sade scholar Maurice Heine, who, in one text, counterposed the dubious pleasures of torture to what Vaneigem describes as the 'negation of a slow reification'. It is better, in other words, for man to become instrumentalized at the hands of another man than by the State. Vaneigem's sense that Surrealism was essentially too humanist, too 'romantic', leads him to make the telling point that its fundamental aversion to modern industry and its anti-functionalism (an attitude, incidentally, which Dada hardly shared, although it was deeply ironical towards the machine) meant that Surrealism was incapable of binding modern technology to its vision. As a result, that vision, in Vaneigem's words, 'became co-opted by the dominant mechanisms of deception and fascination'. It is hard to know precisely what Vaneigem would have wanted the Surrealists to do, beyond embracing mass reproduction in the way that Walter Benjamin

advocated, but he makes the valid point that Surrealism's understanding of modernization was insufficient for it to resist commodification. This critique was in line with Vaneigem's position as a Situationist, opposed to what Debord called 'The Society of the Spectacle,' a world where capital had congealed into an enveloping sensorium.

It is undoubtedly this sense that Surrealism lacked the resources to resist its own assimilation into capitalism that makes one wary of advocating its 'continuation'. Indeed, in its popular forms, Surrealism can be understood as constituting the ideology it professed to oppose, caught in a distorting mirror. In an essay entitled 'Looking Back on Surrealism' the Marxist theorist Theodor Adorno adapted the insights of his colleague Walter Benjamin to suggest that Surrealism, in being predicated on the use of montage, recirculated an image-culture from an earlier stage of capitalism, thereby producing a revelatory jolt of recognition for its viewers. However, its reliance on these obsolescent materials gave it a lifeless, simulacral cast. In Marxist terms, it exemplified man's 'reification' under capitalism.

But can we say that Dada has survived any better than this? At the risk of appearing anachronistic, I want to finish with Vaneigem's polemical *The Revolution of Everyday Life*, written in the build-up to 1968, in which Dada, rather than Surrealism, provides the model of radicalized cultural practice. Seeing Dada's nihilism as the jumping-off point for social revolution, Vaneigem castigates Surrealism for not 'beginning again with Dada's initial nihilism, without basing itself on Dada-anti-Dada, without seeing Dada historically'. We might, of course, be tempted to castigate Vaneigem for not understanding *Dada* historically. We have seen that Dada did not simply amount to nihilism. It was far more mystical than the Situationists would have liked. But its reserves of awkwardness and its love of paradox and effrontery, which even today make it 'difficult' for many, are an antidote to Surrealism's relatively untroubled assimilation into the spectacle.

As well as clarifying their historical and philosophical contours, this book has continually weighed Dada and Surrealism against one another. Surrealism has necessarily taken up more of the discussion because, as well as lasting longer as a movement, its theoretical premises were far more rigorously formulated. It seems appropriate, however, to finish with a reversal of the historical formulation by which Dada 'evolved' into the more self-consciously revolutionary Surrealism and to tilt the balance in favour of Dada's short but incendiary moment. As Vaneigem, with an exuberance now foreign to us, declares: 'The beginning of Dada was the rediscovery of lived experience and its possible delights – its end was the reversal of all perspectives, the invention of a new universe.'

References

Chapter 1

Tristan Tzara, 'Zurich Chronicle', in R. Motherwell (ed.), *The Dada Painters and Poets* (Belknap, 1989), p. 236

Hans Arp, 'Dadaland', tr. H. Richter, in *Dada: Art and Anti-Art* (Thames & Hudson, 1965), p. 25

Hugo Ball, *Flight Out of Time*, tr. A. Raimes, ed. J. Elderfield (University of California Press, 1996), p. 63

Richard Huelsenbeck, 'Dada Lives', *Transition*, 25 (Fall 1936), 77–80

Richard Huelsenbeck, 'Dada Manifesto 1918', in R. Motherwell (ed.), *Dada Painters*, pp. 244, 243

Tristan Tzara, 'Dada Manifesto' (1918), in *Seven Dada Manifestoes and Lampisteries*, tr. B. Wright (John Calder, 1981), p. 5

Francis Picabia, 'Cannibal Manifesto', in R. Huelsenbeck (ed.), *Dada Almanach*, new edn. presented by M. Green (Atlas, 1993), pp. 55–6

André Breton, 'Après Dada', *Comedia* (March 1922)

André Breton, 'First Surrealist Manifesto', in *Manifestoes of Surrealism*, tr. R. Seaver and H. R. Lane (University of Michigan, 1972), pp. 26, 10

Chapter 2

André Breton, 'Rather Life' (Clair de Terre, 1930), from André Breton, 'Selected Poems', tr. Kenneth White (Cape Editions, 1969)

Hugo Ball, *Flight Out of Time*, pp. 70–71

Salvador Dalí, 'The Conquest of the Irrational', tr. H. Finkelstein, in *The Collected Writings of Salvador Dalí* (Cambridge University Press, 1998), p. 265

George Orwell, 'Benefit of Clergy: Some Notes on Salvador Dalí' (1944), *Essays*, ed. J. Carey (Everyman, 2002), pp. 654, 660

Marcel Duchamp, 'The Richard Mutt Case', *The Blind Man*, 2 (1917)

André Breton, 'Marcel Duchamp', tr. M. Polizzotti, in A. Breton, *The Lost Steps* (University of Nebraska Press, 1996), p. 86

Benjamin Péret, 'The Chicago Eucharist Congress', from *Remove Your Hat and Other Writings*, tr. D. Gascoyne and H. Jennings (Atlas, 1986), p. 37

Walter Benjamin, 'Surrealism: The Last Snapshot of the European Intelligentsia', in W. Benjamin, *Reflections*, ed. P. Demetz, tr. E. Jephcott (Harcourt Brace Jovanovich, 1978), p. 182

George Grosz, letter to Otto Schmalhausen, 15 December 1917, from H. Knust, *George Grosz* (Hamburg, 1979), pp. 56–7

Louis Aragon, *Paris Peasant*, tr. Simon Watson Taylor (Pan Books, 1980), p. 52

Chapter 3

Hugo Ball, 'Dada Manifesto' (1916), in *Flight Out of Time*, p. 221

Kurt Schwitters, 'Murder Machine 43', in K. Schwitters, *Poems Performance Pieces Proses Plays Poetics*, ed. J. Rothenberg and P. Jorris (Temple University, 1993), p. 29

Paul Eluard, *L'Amour la poésie* (Gallimard, 1922), p. 122

André Breton, 'Free Union', tr. R. Howard, in Maurice Nadeau, *The History of Surrealism* (Penguin, 1978), pp. 309–10

Benjamin Péret, 'Quatre à Quarte' from 'De Derrière Les Fagots' (1934), tr. A. Balakian in her *Surrealism: The Road to the Absolute* (Unwin Books, 1972), p. 151

Tristan Tzara, 'Dada Manifesto 1918', in *Seven Dada Manifestoes*, p. 5

Excerpt from the trances from André Breton, 'Entrée des Médiums', tr. M. Polizzotti, in A. Breton, *The Lost Steps*, p. 94

Hans Arp, 'Dadaland', in his *On my Way: Selected Poetry and Essays* (Wittenborn, Schultz, 1948), pp. 46, 40

Tristan Tzara, 'Dada Manifesto 1918', in *Seven Dada Manifestoes*, p. 9

Susan Sontag, *On Photography* (Penguin, 1977), p. 52

André Breton, 'Introduction to the Discourse on the Paucity of Reality',
tr. B. Imbs, in A. Breton, *What is Surrealism? Selected Writings*, ed.
F. Rosemont (Pluto, 1978), p. 26

Salvador Dalí, *This Quarter* (Paris, 1932), p. 199

Meret Oppenheim (on 'My Nurse'), text by Jennifer Mundy, *Surrealism:
Desire Unbound* (Tate Publishing, 2001), p. 45

Georges Bataille, 'L'Esprit moderne et le jeu des transpositions',
Documents, 8 (1930), 490–1

Chapter 4

Tristan Tzara, 'Dada Manifesto 1918', from *Seven Dada Manifestoes*, pp. 5, 8

Louis Aragon, *Treatise on Style*, tr. A. Waters (University of Nebraska,
1991), p. 72

Wieland Herzfelde, catalogue of the First International Dada Fair,
Berlin, 1920

Raoul Hausmann, 'Dada in Europa', *Der Dada*, 3 (April 1920)

André Breton, Second Manifesto of Surrealism, in *Manifestoes of
Surrealism*, p. 123

Berlin Dada members, 'Legen Sie Ihr Geld in Dada!', *Der Dada*, 1
(June 1919)

André Levisan (on Mary Wigman), *Theatre Arts* (Feb. 1929), 144

Hugo Ball, 'Occultism and Other Things Rare and Beautiful', as quoted
by Hans Arp, 'Dadaland', in *On my Way*, p. 40

George Grosz, 'Kaffeehaus', *Neue Blätter für Kunst und Dichtung*, 1
(Nov 1918), p. 155

André Breton, *Qu'est ce que le surréalisme?* (Paris, 1934), p. 25

Excerpt from the 'Recherches sur la sexualité', eleventh session, 26
January 1931, tr. J. Imrie, in J. Pierre (ed.), *Investigating Sex:
Surrealist Discussions 1928–1932* (Verso, 1992), pp. 196–7.
Aragon's comment was from the second session, published in *La
Révolution Surréaliste*, 11 (Mar. 1928).

Chapter 5

André Breton, Second Surrealist Manifesto in *Manifestoes of
Surrealism*, p. 128

Whitney Chadwick, *Women Artists and the Surrealist Movement* (Thames & Hudson, 1985), p. 13

Marcel Duchamp, *The Bride Stripped Bare by her Bachelors, Even* (The 'Green Box' notes), tr. George Heard Hamilton (Percy Lund, Humphries & Co. and George Wittenborn, 1960), unpaginated

Hugo Ball, as quoted in Hans Richter, *Dada: Art and Anti-Art*, p. 23

Documents, definition of 'man', tr. I. White, in Robert Lebel and Isabelle Waldberg (eds.), *Encyclopaedia Acephalic* (Atlas, 1995), p. 56

Aimé Césaire, *Return to my Native Land*, tr. J. Berger and A. Bostock (Penguin, 1969), p. 49

Wifredo Lam, as quoted in Max-Pol Fouchet, *Wifredo Lam* (New York, 1976), p. 199

André Breton, 'The Presence of the Gauls', in his *Surrealism and Painting*, tr. Simon Watson Taylor (Icon Editions, 1972), p. 333

Raoul Hausmann, 'Pamphlet gegen die Weimarische Lebensauffassung' (164/1: 44), as cited by Richard Sheppard, *Modernism – Dada – Postmodernism* (Northwestern University Press, 2000), p. 336

André Breton, Diego Rivera, and Leon Trotsky, 'Towards a Free Revolutionary Art', tr. in Charles Harrison and Paul Wood, *Art in Theory 1900–1990* (Blackwells, 1992), p. 529

Tristan Tzara, 'La Surréalisme et l'après-guerre' (Paris 1948), tr. in Helen Lewis, *Dada Turns Red* (Edinburgh University Press, 1990), p. 164

André Breton, 'Charles Fourier', in his *Anthology of Black Humour*, tr. M. Polizzotti (City Light Books, 1997), p. 39

Chapter 6

Hal Foster, 'L'Amour Faux', *Art in America* (Jan. 1986), p. 128

Guy Debord, 'Excerpt from Report on the Construction of Situations and on the International Situationist Tendency's Conditions of Organisation and Action' (June 1957), as reprinted in Iwona Blazwick (ed.), *An Endless Passion . . . an Endless Banquet* (ICA and Verso, 1989), p. 26

Raoul Vaneigem, *The Revolution of Everyday Life*, tr. J. Fullerton and P. Sieveking (Rising Free Collective, 1979), p. 177

Further reading

Many key primary sources have been cited as references. The following are also useful.

Edited collections

Robert Motherwell, *The Dada Painters and Poets* (Harvard University Press, 1989); Lucy Lippard, *Dadas on Art* (Prentice Hall, 1971); Franklin Rosemont (ed.), *André Breton: What is Surrealism? Collected Writings* (Pluto Press, 1978); Mary Ann Caws, *Surrealist Painters and Poets* (MIT Press, 2001).

English translations of important works

Richard Huelsenbeck, *Memoirs of a Dada Drummer* (University of California Press, 1991); André Breton, *Nadja* (Grove Press, 1960) and *Mad Love* (University of Nebraska Press, 1987); Georges Bataille, *Visions of Excess*, ed. A. Stoekl (Manchester University Press, 1985) and *The Story of the Eye* (Penguin, 1982).

Reprints of Dada and Surrealist journals

Dada (Zurich Reviews, Jean-Michel Place, 1981), *391* (Editions Pierre Belford, 1975), *La Révolution Surréaliste* (J.-M. Place, 1975), *Le Surréalisme au Service de la Révolution* (J.-M. Place, 1976), *Minotaure* (Flammarion, 1981), *Documents* (J.-M. Place, 1991).

Chapter 1

Although contested now, Peter Bürger, *The Theory of the Avant Garde* (University of Minnesota, 1984), is the key work on its topic. The best general history is Dawn Ades, *Dada and Surrealism Reviewed* (Arts Council of Great Britain, 1978), with its emphasis on both movements' publications, but see also Matthew Gale's chronology, *Dada and Surrealism* (Phaidon, 1997). In terms of Dada, a major eight-volume study is in progress, with each volume dedicated to a different centre (ed. Stephen Foster, G. K. Hall & Co., 1996–). Richard Sheppard's *Modernism – Dada – Postmodernism* (Northwestern University Press, 2000) collects his important essays on Dada together. For branches of Dada see: Francis Nauman, *New York Dada 1915–1923* (Harry N. Abrams, 1994); Michel Sanouillet, *Dada à Paris* (Flammarion, 1993); Robert Short, 'Paris Dada and Surrealism,' Dada: *Studies of a Movement*, ed. R. Sheppard (Alpha Academica, 1979); and the essays in Stephen Foster and Rudolf Kuenzli, *Dada Spectrum: The Dialectics of Revolt* (Coda, 1979). On Surrealism, see Maurice Nadeau's pioneering *The History of Surrealism* (Penguin, 1973); Gérard Durozoi's monumental *History of the Surrealist Movement* (University of Chicago Press, 2002); and the relevant sections of Briony Fer, David Batchelor, and Paul Wood, *Realism, Rationalism, Surrealism: Art between the Wars* (Yale University Press, 1993) and Christopher Green, *Cubism and its Enemies* (Yale University Press, 1987).

Chapter 2

Aspects of the first two sections were suggested by Debbie Lewer's essay on mapping Zurich Dada in B. Pichon and K. Riha (eds.), *Dada Zurich: A Clown's Game from Nothing* (New York, 1996); Philip Mann's *Hugo Ball* (University of London, 1987); Annabelle Melzer's excellent *Dada and Surrealist Performance* (Johns Hopkins University Press, 1976); Lewis Kachur's *Displaying the Marvellous* (MIT Press, 2001) and chs. 6 and 7 of Bruce Altschuler's *The Avant Garde in Exhibition* (Abrams, 1994). On Arthur Cravan see Roger Conover *et al.*, *Four Dada Suicides* (Atlas, 1995). For Marcel Duchamp the standard biography is Calvin Tomkins, *Duchamp: A Biography* (Chatto & Windus, 1997) but see also Dawn Ades,

Neil Cox, and David Hopkins, *Marcel Duchamp* (Thames & Hudson, 1999).

The best monograph on Salvador Dalí is Dawn Ades, *Dalí* (Thames & Hudson, 1982). Aspects of the last two sections are indebted to Robin Walz, *Pulp Surrealism* (University of California Press, 2000); Sherwin Simons, 'Advertising Seizes Control of Life . . . ', *Oxford Art Journal*, 22/1 (1999); and Roger Cardinal, 'Soluble City', *Architectural Design*, 2–3 (1978). For Hal Foster on modernity and Surrealism see his *Compulsive Beauty* (MIT Press, 1993), ch. 6.

Chapter 3

Clement Greenberg's Modernist attack on Surrealism is his 'Surrealist Painting', *Horizon* (Jan. 1945). For poetry see Anna Balakian, *Surrealism: The Road to the Absolute* (Unwin Books, 1972). Dawn Ades's essay on the 'mouvement flou' in T. A. R. Neff (ed.), *In the Mind's Eye: Dada and Surrealism* (Museum of Contemporary Art, Chicago, 1984) is excellent. See also Harriet Watts, *Chance: A Perspective on Dada* (UMI Research Press, 1980) and Alastair Grieve's essay on early Arp, 'Arp in Zurich' (in Foster and Kuenzli, *Dada Spectrum*). The standard survey of photomontage is by Dawn Ades (Thames & Hudson, 1986) but see also Maud Lavin's excellent *Cut with the Kitchen Knife: The Weimar Photomontages of Hannah Höch* (Yale University Press, 1993). The attacks on Surrealist painting were Max Morise, 'Les Yeux enchantés', *La Révolution Surréaliste*, 1 (Dec. 1924) and Pierre Naville, *La Révolution Surréaliste*, 3 (15 April 1925). There are numerous monographs on individual Dadaist and Surrealist artists, but see William Camfield, *Francis Picabia* (Princeton University Press, 1979) and *Max Ernst: Dada and the Dawn of Surrealism* (Prestel, 1993); Hans Hess, *George Grosz* (Yale University Press, 1985); Jacques Dupin, *Joan Miró* (Thames & Hudson, 1962); William Rubin and Carolyn Lanchner, *André Masson* (Museum of Modern Art, New York, 1976); and David Sylvester, *Magritte* (South Bank Centre, London, 1992). For Surrealist photography see Rosalind Krauss and Jane Livingston, *L'Amour Fou: Photography and Surrealism* (Abbeville, 1985). For the Surrealist object and fetishism see Dawn Ades, 'Fetishism's Job', in

A. Shelton (ed.), *Fetishism: Visualising Power and Desire* (South Bank Centre, London, 1995) and for Meret Oppenheim, see Edward D. Power, 'These Boots Ain't Made for Walking', *Art History*, 24/3 (June 2001). On film see A. L. Rees, *A History of Experimental Film and Video* (British Film Institute, 1999); Rudolf Kuenzli (ed.), *Dada and Surrealist Film* (William Locker & Owens, 1987); and Linda Williams, *Figures of Desire* (University of California Press, 1981). For Fredric Jameson see his *Marxism and Form* (Princeton University Press, 1971), pp. 95–106.

Chapter 4

On Dada irrationalism see Richard Sheppard, *Modernism*, ch. 7. For Surrealism's psychoanalytic links see Elisabeth Roudinesco, *Jacques Lacan and Co: A History of Psycho-Analysis in France 1925–1985* (Free Association, 1990), part one. On Ernst's 'Pietà' see Malcolm Gee, *Ernst/Pietà or Revolution by Night* (Tate Gallery, 1986) and for psychoanalysis in Surrealist art, David Lomas, *The Haunted Self* (Yale University Press, 2000). Dada attitudes to the machine, and Cartesian dualism, are dealt with in my *Marcel Duchamp and Max Ernst: The Bride Shared* (Oxford University Press, 1998), chs. 1 and 2. For Bataille's thought see Michael Richardson, *Bataille* (Routledge, 1994) as well as Bataille's own writings as cited above. Richard Sheppard is again excellent on Dada and mysticism (*Modernism*, ch. 10) but see also Timothy O. Benson's essay 'Mysticism, Materialism and the Machine in Berlin Dada', *Art Journal*, 46/1 (Spring 1987). Alchemy in Surrealism is discussed in my *Marcel Duchamp and Max Ernst*. For Miró and Lull see also my 'Ramon Lull, Miró and Surrealism', *Apollo* (Dec. 1993). For the idea of the Wunderkammer see the final chapter of my *Marcel Duchamp and Max Ernst*, and for Joseph Cornell see Diane Waldman, *Joseph Cornell: Master of Dreams* (Harry N. Abrams, 2002). Jan Švankmajer's text on 'Fellaceus Oedipus' appears in *Jan Švankmajer: Transmutation of the Senses* (Central Europe Gallery and Publishing House, 1994), pp. 23–4. Ideas of traumatic mimickry in Berlin Dada are developed by Brigid Doherty in 'See: We are All Neurasthenics: Or, the Trauma of Dada, Montage', *Critical Inquiry*, 24 (Autumn 1997). For the effects of World War 1 on male Surrealist imagery see Amy Lyford: *Surrealist*

Masculinities (forthcoming, University of California Press). On Surrealist sexuality see Jennifer Mundy (ed.), *Surrealism: Desire Unbound* (Tate Publishing, 2001), which includes an excellent essay on Sade by Neil Cox, and Xavière Gauthier, *Surréalisme et Sexualité* (Gallimard, 1971). Recent monographs on Bellmer are by Sue Taylor, *Hans Bellmer: The Anxiety of Influence* (MIT, 2000) and Therese Lichtenstein, *Behind Closed Doors: The Art of Hans Bellmer* (University of California, 2001).

Chapter 5

See Naomi Sawelson-Gorse (ed.), *Women in Dada* (MIT, 1998) and Whitney Chadwick, *Women Artists and the Surrealist Movement* (Thames & Hudson, 1995). For Elisabeth Roudinesco see her *Jacques Lacan and Co*, and for Krauss's women-under-construction argument see Rosalind Krauss and Jane Livingston, *L'Amour Fou*, ch. 2. For Susan Rubin Suleiman see her *Subversive Intent* (Harvard University Press, 1991), chs. 1, 7. Recent essays on Claude Cahun and Frida Kahlo appear in Whitney Chadwick (ed.), *Mirror Images: Women, Surrealism and Representation* (MIT Press, 1998). For the Baroness see the biography *Baroness Elsa*, by Irene Gammel (MIT, 2002). For masculinity in Surrealism see my 'Male Shots', *Tate: The Art Magazine*, 26 (Aug. 2001). On Duchamp as Rrose Sélavy see Amelia Jones, *Postmodernism and the En-Gendering of Marcel Duchamp* (Cambridge University Press, 1994), ch. 5, and my 'Men Before the Mirror: Duchamp, Man Ray and Masculinity', *Art History*, 21/3 (Sept. 1998).

For a general essay on 'primitivism', and a more specific one on Giacometti, see Evan Maurer and Rosalind Krauss in William Rubin (ed.), *Primitivism in 20th Century Art* (Museum of Modern Art, New York, 1984), vol. ii. The best introduction to ethnography and Surrealism is James Clifford, *The Predicament of Culture* (Harvard University Press, 1988), part two, but see also Denis Hollier, 'The Use-Value of the Impossible', *October*, 60 (Spring 1992). On anti-colonialism see Michael Richardson and Krzysztof Fijalkowski, *The Refusal of the Shadow: Surrealism and the Caribbean* (Verso, 1996). A useful essay on Wifredo Lam is Robert Linsley, 'Wifredo Lam: Painter of Negritude',

Art History, 11/4 (Dec. 1988). For Alejo Carpentier on Surrealism see the prologue to his novel *The Kingdom of the World* (André Deutsch, 1991). For Eastern European and Japanese Dada see Gerald Janecek and Toshiharu Omuka (eds.), *The Eastern Dada Orbit* (G. K. Hall & Co., 1998). Dada politics are discussed in Richard Sheppard, *Modernism*, ch. 12, and the important essays by Christopher Middleton in section 1 of his *Bolshevism in Art* (Carcanet New Press, 1978). John Willett's *The New Sobriety* (Thames & Hudson, 1978) is a classic study. In terms of Surrealism, see Steven Harris: *Surrealist Art and Thought in the 1930s: Art, Politics and Psyche*, Cambridge University Press, 2004. Helena Lewis, *Dada Turns Red* (Edinburgh University Press, 1988) is useful, despite some factual errors, while Michael Richardson and Krzysztof Fijalkowski, *Surrealism Against the Current: Tracts and Declarations* (Pluto, 2001) collects a number of important political texts. On Fourier see André Breton's *Ode to Charles Fourier*, tr. K. White (Cape Goliard, 1969) and Raoul Vaneigem's *A Cavalier History of Surrealism*, tr. D. Nicholson Smith (AK Press, 1999).

Chapter 6

For the general take-up of Dada and Surrealism in post-1945 art see my *After Modern Art 1945–2000* (Oxford University Press, 2000). Theodor Adorno's essay 'Looking Back on Surrealism' is in his *Notes to Literature* (Columbia University Press, 1991). For Situationism and Surrealism see Peter Wollen's essay in *on the passage of a few people through a certain moment in time* (MIT, 1991) and Vaneigem, as in references.

Dada: the main centres – key individuals and events

Zurich

Hans/Jean Arp (Alsatian, 1887–1966)

Hugo Ball (German, 1896–1927)

Viking Eggeling (Swedish, 1880–1925)

Marcel Janco (Romanian, 1895–1984)

Hans Richter (German, 1888–1976)

Walter Serner (Czech, 1889–1942)

Sophie Taeuber (Swiss, 1889–1943)

Tristan Tzara (Romanian, 1896–1963)

Feb 1916: Opening of Cabaret Voltaire

April 1916: The name 'Dada' invented

June 1916: First Dada journal, *Cabaret Voltaire*

March–May 1917: Galerie Dada

July 1917: First issue of *Dada* journal

1918: Tristan Tzara's *Dada Manifesto*

April 1919: Serner's *Last Loosening Manifesto*

New York

Arthur Cravan (Swiss, 1887–1920)

Marcel Duchamp (French, 1887–1968)

Elsa von Freytag-Loringhoven (German, 1874–1927)

Francis Picabia (French, 1879–1953)

Man Ray (American, 1890–1976)

June 1915: Duchamp arrives in New York

January 1917: Picabia's journal *391* first published from Barcelona

April 1917: Duchamp's *Fountain* rejected by jury of 'Independents' exhibition

April 1917: Arthur Cravan delivers drunken lecture at 'Independents'

Berlin

Johannes Baader (German, 1875–1955)

George Grosz (German, 1893–1959)

Raoul Hausmann (German, 1866–1971)

John Heartfield (German, 1891–1968)

Wieland Herzfelde (German, 1896–1988)

Hannah Höch (German, 1889–1978)

Richard Huelsenbeck (German, 1892–1974)

Walter Mehring (German, 1896–1981)

April 1918: Huelsenbeck founds Club Dada

February 1919: *Jedermann sein eigner Fussball* published and distributed

1919: First issues of *Der Dada* and *Die Pleite*

June 1920: International Dada Fair

Cologne

Max Ernst (German, 1891–1976)

Johannes Baargeld (German, 1892–1927)

Heinrich Hoerle (German, 1895–1936)

1919: publication of journals, *Der Ventilator* and *Bulletin D*

April 1920: Cologne Dada Fair

Hanover

Kurt Schwitters (German, 1887–1949)

1920: Beginning of 'Merz'

Paris

Louis Aragon (French, 1897–1982)

André Breton (French, 1896–1966)

Paul Eluard (French, 1895–1952)

1919: Beginning of journal *Littérature*

André Breton and Philippe Soupault publish *Les Champs Magnétiques*

Paris

Philippe Soupault (French, 1897–1990)	1920: Picabia's *Cannibal Manifesto*
	May 1921: Mock trial of Maurice Barrès
	1922: Congress of Rome
	July 1923: Tzara's 'Soirée de la Cœur à Barbe' effectively signals end of Dada

Key Surrealist events

1924 First Surrealist Manifesto

 Opening of Bureau de Recherches Surréalistes

 Founding of the review *La Révolution Surréaliste* (runs until 1929)

1926 Formation of Belgian Surrealist group

1929 Second Surrealist Manifesto

 Breton expels several dissident members of Surrealist group

 Founding of Bataille's journal *Documents*

 Dalí and Buñuel's film *Un Chien Andalou*

1930 Under the title 'Un Cadavre' dissident Surrealists launch attack on Breton

 Launch of the journal *Le Surréalisme au Service de la Révolution* (runs until 1933)

 Aragon attends the Second International Congress of Revolutionary Writers, Kharkov, Russia

1932 Aragon breaks with the Surrealist group

1933 Founding of journal *Minotaure* (runs until 1939)

1934 Prague Surrealist group established

 International Surrealist Exhibition, London

 Exhibition of Surrealist Objects, Charles Ratton gallery, Paris

1938 Breton and Trotsky collaborate on the manifesto 'Towards an Independent Revolutionary Art'

 'Exposition Internationale du Surréalisme' at Galerie Beaux-Arts, Paris

1941 Breton and other refugees from Europe arrive in New York

1942 'First Papers of Surrealism' exhibition, New York

1946 Breton returns to France

Key figures associated with Surrealism

Writers

Louis Aragon (French, 1897–1982)

Antonin Artaud (French, 1896–1948)

Georges Bataille (French, 1897–1962)

André Breton (French, 1896–1966)

René Crevel (French, 1900–35)

Robert Desnos (French, 1900–45)

Paul Eluard (French, 1895–1952)

Maurice Heine (French, 1884–1946)

Georges Hugnet (French, 1906–74)

Michel Leiris (French, 1901–90)

Pierre Mabille (French, 1904–52)

Pierre Naville (French, 1903–93)

Paul Nougé (Belgian, 1895–1976)

Benjamin Péret (French, 1899–1959)

Jacques Prévert (French, 1900–77)

Raymond Queneau (French, 1903–76)

Artists

Hans Bellmer (German, 1902–75)

Luis Buñuel (Spanish, 1900–83)

Claude Cahun (French, 1894–1954)

Joseph Cornell (American, 1903–72)

Salvador Dalí (Spanish, 1904–89)

Giorgio de Chirico (Italian, 1888–1978)

Max Ernst (German, 1891–1976)

Alberto Giacometti (Swiss, 1901–66)

Frida Kahlo (Mexican, 1907–54)

René Magritte (Belgian, 1898–1967)

Man Ray (American, 1890–1976)

André Masson (French, 1896–1987)

Joan Miró (Spanish, 1893–1983)

Meret Oppenheim (Swiss, 1913–85)

Pablo Picasso (Spanish, 1881–1973)

Yves Tanguy (French, 1900–55)

Index

D

index

index

Expand your collection of
VERY SHORT INTRODUCTIONS

Visit the
VERY SHORT
INTRODUCTIONS
Web site

www.oup.co.uk/vsi

➤ **Information** about all published titles

➤ News of **forthcoming books**

➤ **Extracts** from the books, including titles
not yet published

➤ **Reviews** and views

➤ **Links** to other **web sites** and main
OUP web page

➤ Information about **VSIs in translation**

➤ **Contact** the editors

➤ **Order** other **VSIs** on-line

PHILOSOPHY
A Very Short Introduction
Edward Craig

This lively and engaging book is the ideal introduction for anyone who has ever been puzzled by what philosophy is or what it is for.

Edward Craig argues that philosophy is not an activity from another planet: learning about it is just a matter of broadening and deepening what most of us do already. He shows that philosophy is no mere intellectual pastime: thinkers such as Plato, Buddhist writers, Descartes, Hobbes, Hume, Hegel, Darwin, Mill and de Beauvoir were responding to real needs and events – much of their work shapes our lives today, and many of their concerns are still ours.

'A vigorous and engaging introduction that speaks to the philosopher in everyone.'

John Cottingham, University of Reading

'addresses many of the central philosophical questions in an engaging and thought-provoking style ... Edward Craig is already famous as the editor of the best long work on philosophy (the Routledge Encyclopedia); now he deserves to become even better known as the author of one of the best short ones.'

Nigel Warburton, The Open University

www.oup.co.uk/isbn/0-19-285421-6

POSTMODERNISM
A Very Short Introduction

Christopher Butler

Postmodernism has become the buzzword of contemporary society over the last decade. But how can it be defined? In this Very Short Introduction Christopher Butler lithely challenges and explores the key ideas of postmodernism, and their engagement with literature, the visual arts, film, architecture, and music. He treats artists, intellectuals, critics, and social scientists 'as if they were all members of a loosely constituted and quarrelsome political party' – a party which includes such members as Jacques Derrida, Salman Rushdie, Thomas Pynchon, David Bowie, and Micheal Craig-Martin – creating a vastly entertaining framework in which to unravel the mysteries of the 'postmodern condition', from the politicizing of museum culture to the cult of the politically correct.

> 'a preeminently sane, lucid, and concise statement about the central issues, the key examples, and the notorious derilections of postmodernism. I feel a fresh wind blowing away the miasma coiling around the topic.'
>
> **Ihab Hassan, University of Wisconsin, Milwaukee**

www.oup.co.uk/isbn/0-19-280239-9

INTELLIGENCE
A Very Short Introduction
Ian J. Deary

Ian J. Deary takes readers with no knowledge about the science of human intelligence to a stage where they can make informed judgements about some of the key questions about human mental activities. He discusses different types of intelligence, and what we know about how genes and the environment combine to cause these differences; he addresses their biological basis, and whether intelligence declines or increases as we grow older. He charts the discoveries that psychologists have made about how and why we vary in important aspects of our thinking powers.

'There has been no short, up to date and accurate book on the science of intelligence for many years now. This is that missing book. Deary's informal, story-telling style will engage readers, but it does not in any way compromise the scientific seriousness of the book . . . excellent.'

Linda Gottfredson, University of Delaware

'Ian Deary is a world-class leader in research on intelligence and he has written a world-class introduction to the field . . . This is a marvellous introduction to an exciting area of research.'

Robert Plomin, University of London

www.oup.co.uk/isbn/0-19-289321-1